# THE ART OF FAERY

FOREWORD BY BRIAN FROUD
PRESENTED BY DAVID RICHÉ

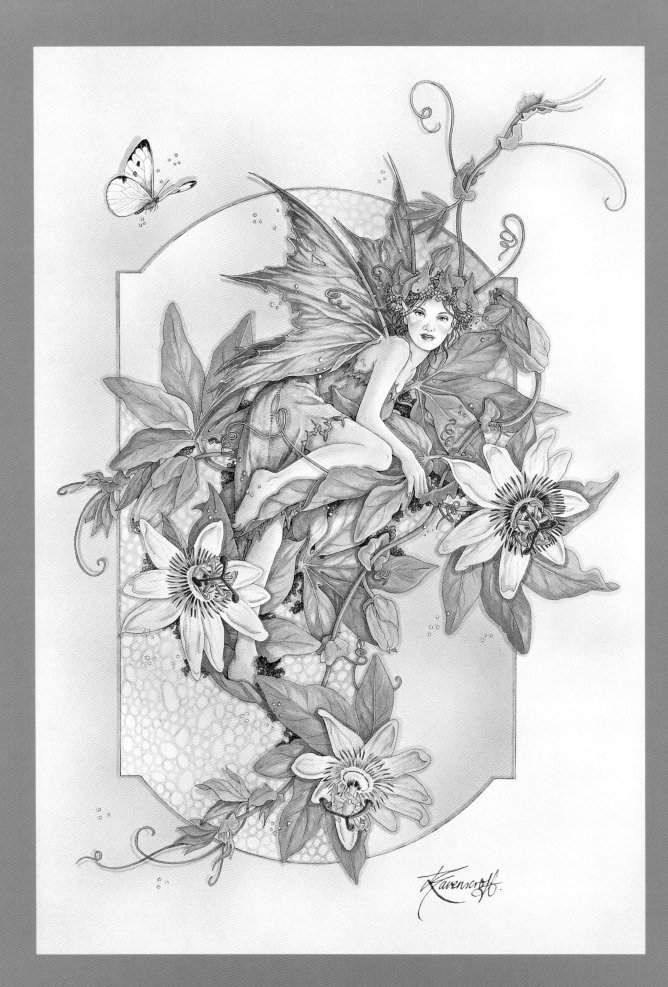

# THE ART OF FAERY

FOREWORD BY BRIAN FROUD

PRESENTED BY DAVID RICHÉ

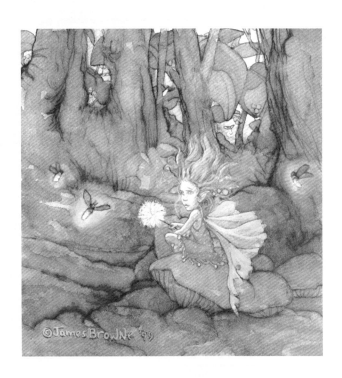

Paper Tiger

For Myrea.
It is the way the trees are, and the Faery I believed in who showed me nothing happens unless first a dream.

First published in Great Britain in 2003 by
Paper Tiger
The Chrysalis Building
Bramley Road
London W10 6SP

An imprint of **Chrysalis** Books Group plc

3 5 7 9 8 6 4

British Library Cataloguing-in-Publication Data:
A catalogue record for this book is available from the British Library.

ISBN 1 84340 095 2

Designed by Malcolm Couch
Project managed by Miranda Sessions
Edited by Paul Barnett

Reproduction by Classic Scan Pte Ltd, Singapore
Printed and bound by Times Offset (M) Sdn. Bhd, Malaysia

**Front Jacket**: David Delamare *A Little Night Music*
**Back Jacket**: (Top) Myrea Pettit *The Empress Fairy*
(Bottom) Amy Brown *Gothic*
**Left Flap**: James Browne *A'mour*
**Right Flap**: John Arthur *Raina The Fairy Princess*
**Page 2**: Linda Ravenscroft *Passiflora*
**Page 3**: (Top) Myrea Pettit *The Peacock Rose Ballerina*
(Bottom) James Browne *Light Duster*
**Page 5**: (Top) Myrea Pettit *The Empress Fairy*
(Bottom) Linda Ravenscroft *Oceans Bounty*

**A note on the spelling of 'fairy' 'faery' and 'faerie'.**
*Collins English Dictionary* provides a single entry for "Faerie *or* Faery" and gives the following definitions:
*Archaic or poetic.* **1** the land of fairies. **2** enchantment. *adj, n* **3** a variant of fairy.
All three spelling have been used in this book, in accordance with the preference of the individual artists involved.
This has been done in order to preserve each person's individual style and response to this subject on which they have
written and contributed work.

# CONTENTS

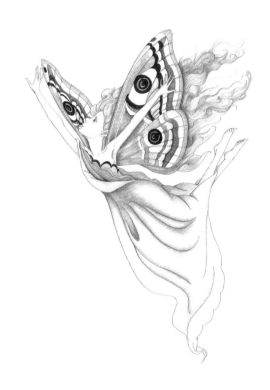

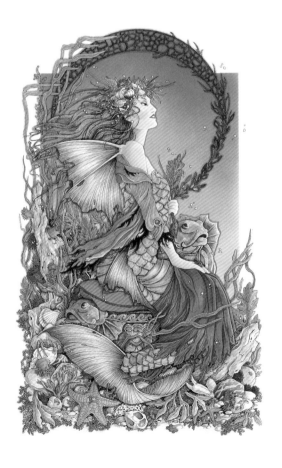

# FOREWORD:
# A VISION FOR THE 21ST CENTURY
## BRIAN FROUD

ONCE UPON A TIME it seemed you could not go out into the world without tripping over a fairy. Fairies lived in the hills, elves lurked behind trees, and a fireside always had its own brownie. Every aspect of the world was vibrant with fairy life. Fairies were our constant companions.

Artists and mystics have always attempted to express the nature of Faery, even though their efforts have often been rewarded with contemporary scorn and derision. And yet the power of Faery is irresistible, for fairies stand at the gateways to insight and wisdom. The ancients knew them; medieval monks drew them in the margins of their manuscripts; Shakespeare wrote of them; the greatest of painters have conjured their forms in line and colour; and poets of genius such as Keats and Yeats have had a profound relationship with the muses of Faery.

But then came the 20th century, and all through it fairies seemed to retreat into their secret places, taking with them their enchantment. Without them, our experience of the world was hollow and grey. Our knowledge of fairies was reduced to the tritest and gaudiest products of the human mind, washed up on the shorelines of nurseries. Towards the end of the century, however, there came a revitalization of Faery and the images of it that human artists created. More and more artists again began to express themselves through the depiction of ethereal fairy forms.

And now it is the 21st century, and the fairies are returning. This book is evidence of that.

Fairies mediate art, the mysterious moments of our creative relationship with the world. Whereas the 20th century in general emphasized our alienation from the world, in its final decade or

SYLPH (*FACING PAGE*)
Acrylics and mixed media. Published in *Good Faeries, Bad Faeries*, 1998.

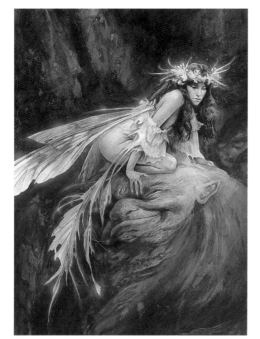

LITTLE NELL *(LEFT)*
Acrylics and mixed media. Published in
*Good Faeries, Bad Faeries*, 1998.

two the resurgence of fairy art, as seen in books and in major museum shows displaying works from past and present, began to reverse this. The process is continuing in this new century of ours.

The visionary art of Faery represents the beginning of a spiritual journey. To paint fairies is not childish, but it could certainly be said to be childlike – child*like* in its openness to creative and emotional impulses. This, of course, is a state that all seers and mystics strive for. To be open to the possibility of feeling the soft breeze created by the wing of a fairy, and to express this in art, is to understand a profound connection to the world and to each other.

This book is a catalogue of fairy art for the 21st century. In its pages you will find artists from different countries and backgrounds, yet all have the common bond of being guides to the realms of Faery. They attempt to reveal the normally unseen. They illuminate the dark inner recesses of nature and our relationship with it. And in so doing they reveal the radiance of Faery.

In his play *Peter Pan*, when Tinkerbell was dying, J.M. Barrie asked audiences to revive her by clapping their hands to show they believed in fairies. This book will undoubtedly receive a thunder of applause.

*Brian Froud*

FAERY GODMOTHER (*FACING PAGE*)
Acrylics and mixed media.
Published in *Good Faeries, Bad Faeries*, 1998.

# JOHN ARTHUR

" *A true faerie is a spirit, a symbol, a metaphor. It can inhabit a tree, a horse, or a figure. We are creating a world of infinite possibility and interpreting it with a finite mind. That's the beauty.* "

John Arthur was born as John Arthur Williams in Peoria, Illinois. His father, an artist himself, taught his young son the basics of drawing and how to "see with a finer eye". A professional artist for over 25 years, John now lives in Crestline, California. His countless clients have included Disney, Warner Bros. and Carlton Greetings.

John regards himself as primarily a figurative artist, and it is from this that his passion for depicting fairies was born: "Traditional faeries have it all. Their natures are playful and mischievous, and on top of that – they can fly! This alone allows for a whole new variety of poses you won't encounter with a gravity-bound figure." Among his influences he lists the Old Masters, such as Michelangelo, Rembrandt, Leonardo, Rubens and Dürer, as well as more recent artists like Rodin, Van Gogh, Degas, Waterhouse,

Sargent, Dalí – and Disney. Illustrators he cites as major influences include Leyendecker, N.C. Wyeth, Parrish, Rackham, Dulac and Rockwell.

As a freelance artist he has taken on all kinds of work, especially in the early days. More recently, while valuing all that he learned from those times, he has been able to concentrate more on the work he wants to do: painting for prints, picture books,

DREAMING IN THE MYSTWOOD (*LEFT*)
11 x 14½ in. Watercolour. 1986.

This is a favourite painting of mine because it was one of the first paintings that I sketched with a ball-point pen. When I then put on the watercolours a nice blue cast appeared from behind the trees. I've used this technique many times since. It's one of my most popular paintings.

FROST FAIRY (*RIGHT*)
7 x 10 in. Watercolour. 1988.

I believe I was looking at Maxfield Parrish book illustrations and experimenting with new watercolour paper at the time I painted this. A nice vignette, I think.

limited-edition portfolios, book covers and the like. He also instructs Master Art seminars, but "I tell all my students to get their degrees in something more stable than art".

He is constantly experimenting with materials, feeling that "they all have a different voice". He went through a phase of using laundry markers on cold-press watercolour paper, and especially enjoys drawing on chipboard with a ballpoint pen. Indeed, the ballpoint pen is a special tool for him: her prefers it to pencils for sketching partly for practical reasons (the points don't keep breaking off), partly because of the spontaneity of the resultant sketches ("no erasing, very direct") and partly because of the effects gained by the blue ink bleeding when he paints on top of it to leave an interesting hue around what he's painted. He experiments with colours, too; currently he prefers bright colours, but he used to work with a more sober palette. In the same experimental spirit he likes his watercolours to be "dirty, cracked and full of debris" because "there's no telling what I might find".

A good selection of his richly rendered fairy paintings can be found at his website: www.johnarthur.com.

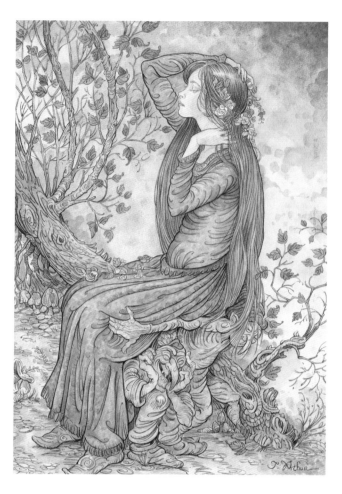

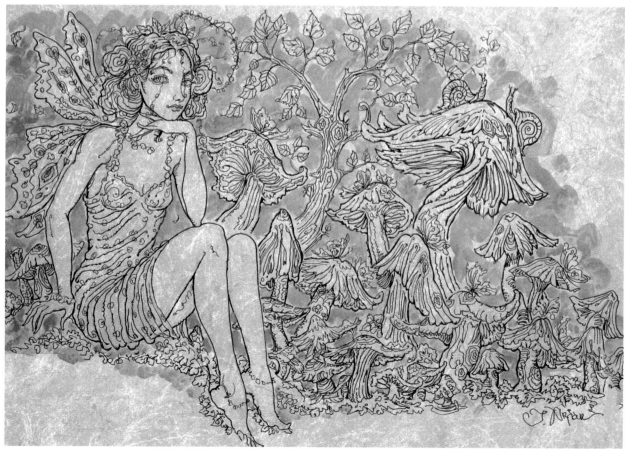

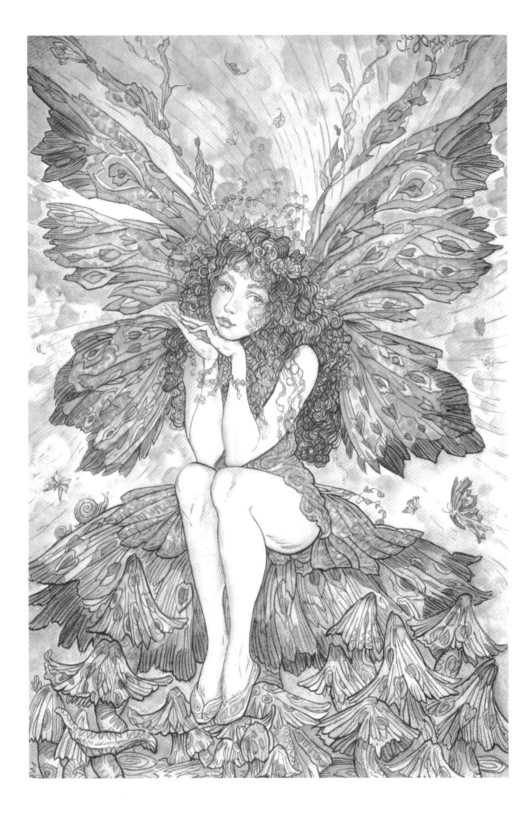

A recent piece. I used a sketch from a model who posed for me many years ago. The pose is very feminine and very like her. As opposed to a colour study, I often make notes on the back of the painting as I draw and, with this one, I stuck pretty close to them. The name "Raina" means peaceful queen.

THE GNOME CHAIR (*FACING PAGE ABOVE*)
12 x 17½ in. Watercolour. 2000.

This is an obvious tribute to John William Waterhouse. I love his work and have always encouraged my students to borrow freely from the Masters. It's not only fun but it is valuable to do this. It's a vicarious experience; much like a virtuoso pianist experiencing Chopin or Beethoven by playing their music.

MEENA THE MUSHROOM FAIRY (*FACING PAGE BELOW*)
12 x 18 in. Pen and ink with gold wash. 2002.

This is another very spontaneous pen and ink figure. I like portable work and I did this at the beach while on holiday. The mushrooms really came alive and take on a whole new look. I used gold acrylic paint for the background wash.

# JULIE BAROH

*" I want to evoke and get to that little part of all our adult minds which is eternally childlike. The work speaks to that portion, and I think that makes it timeless. I want the work to be timeless in its own right. "*

FAIRY BUG (*BELOW*)
4 x 6 in. Gouache and graphite. 1995.

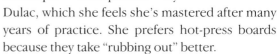

Born in Seattle, Washington State, in 1970, Julie Baroh remembers starting to draw and paint when she was two. Her father was an artist and encouraged her to keep going, but she attributes her early interest to an innate aptitude. She took her Bachelor of Fine Arts course in Seattle, at Cornish College of the Arts. Among her influences she counts book illustrators like Howard Pyle, Arthur Rackham, Edmund Dulac, Edward Gorey, Brian Froud and Alan Lee. Her favourite possession is her first edition of J.M. Barrie's *Peter Pan in Kensington Gardens* (1906), which was illustrated by Rackham.

Julie does both painting and printmaking. For her printmaking she likes using linoleum ("good boxwood is nearly impossible to find these days"), running the prints out on her Vandercook proof press; as paper she uses anything from mulberry to Sommerset [sic]. For her painting she works almost exclusively in gouache and acrylics –

specifically Holbein Acryla – and very occasionally in oils, "but with oils I glaze so much it takes me months to finish anything, even with alkyds". She likes using techniques of glazing and washes, plus the "rub out" technique championed by Dulac, which she feels she's mastered after many years of practice. She prefers hot-press boards because they take "rubbing out" better.

Baroh is a relative newcomer to fairy art, because she "hated drawing wings". However, when she started working for fantasy-games companies like Wizards of the Coast, mainly on magazines and trading cards, she was forced to start depicting fairies. "I dusted off my old Rackham books and my copy of Brian Froud's and Alan Lee's *Faeries* and started basically copying them. I discovered I really liked the little fairies

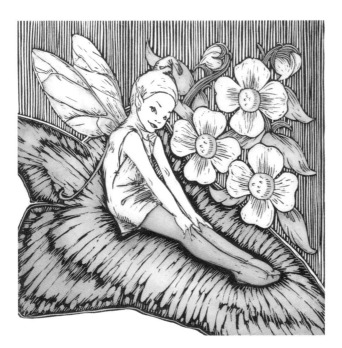

JARDIN FAERIE (*LEFT*)
5 x 5 in. Hand-coloured linocut. 2002.

This is a block print I hand-painted in washes (originally done in black and white). It was fun to do, and the wings were challenging because I had to depict them as transparent.

ELVISH LIBRARIAN (*FACING PAGE, LEFT*)
9 x 14 in. Hand coloured engraving. 2002.

*Elvish Librarian* was the last of a set series of engravings. It exemplifies both my interest in books, as well as a providing a humourous account of the traditional librarian.

FROM *THE LITTLEST PIXIE* (PAGE 3)
(*RIGHT*)
9 x 14 in. Hand coloured engraving. 2002.

This was intended for an unpublished
children's book called *The Littlest Pixie* by
Zoe Kaylor. At this point in the book, the
Littlest Pixie is being tormented by her fellow
pixies for doing "nice" things rather than
mischievous pixie things. I wanted to give the
scene a claustrophobic feeling.

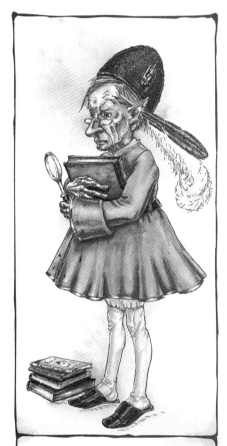

Solomon served as the Elvish Librarian,
and despite his organizational skills
and great knowledge of Lore, he was
nevertheless quite unpopular with the
Elves, and spent his time in solitude.

~*Elfin Hill*

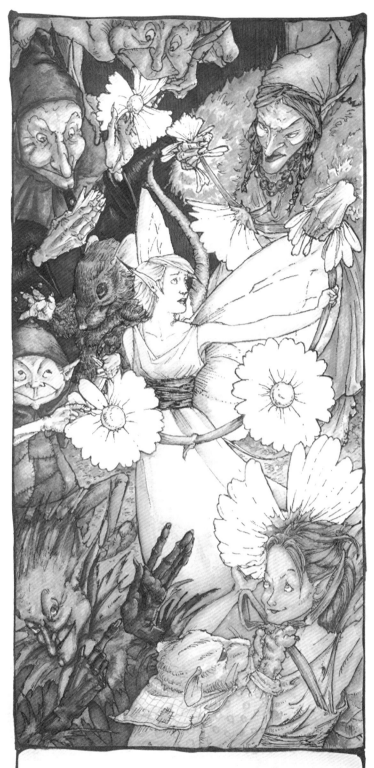

"What's this, necklaces for fairies?!"
as the naughty pixies ripped the
daisy necklaces apart.

~*The Littlest Pixie*

> *"I see my work maturing and coming into its own. I'm still very young and am learning new things all the time. I have no idea what the future will bring. That's the fun of it all."*

and pixies and elves and such; they just came out of my hand and onto the paper." All her fairies, she feels, have their own "little funny personalities". The more conventionally beautiful ones are usually based on models, and she tries to incorporate a spirit of serenity into them. She has a website at www.juliebaroh.com.

Julie looks back on her already successful art career with some wryness. "I really wanted to be an art historian rather than an artist."

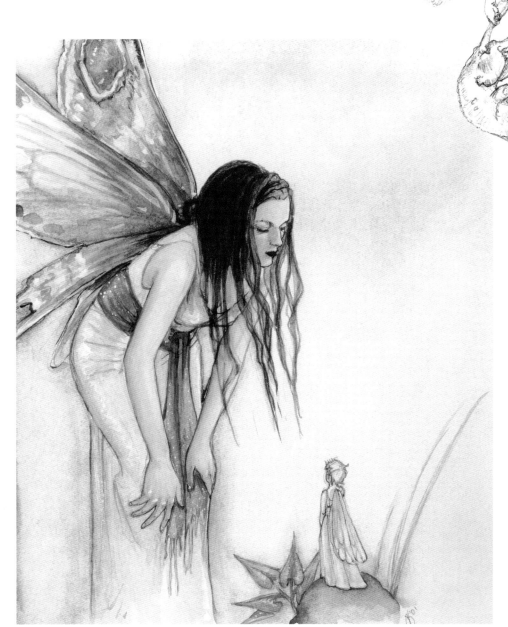

FAIRIE-DEMON (*ABOVE*)
4 x 4 in. Graphite on board.

This was used as spot art for a book. The drawing itself is rather rough, but I think sometimes that roughness gives a piece more character than a "clean" drawing does. Fortunately the art director I worked with at the time felt the same way too, so I was allowed to express myself however I wanted with the series of drawings I did.

STUDY FOR PIXIE (*LEFT*)
4 x 5 in. Gouache. 2001.

This was a study for *The Littlest Pixie*, in which a Faerie Elder consoles the Littlest Pixie after she runs away. It was actually just intended for me to work out the way the Pixie Elder would look, but it came out rather well on its own.

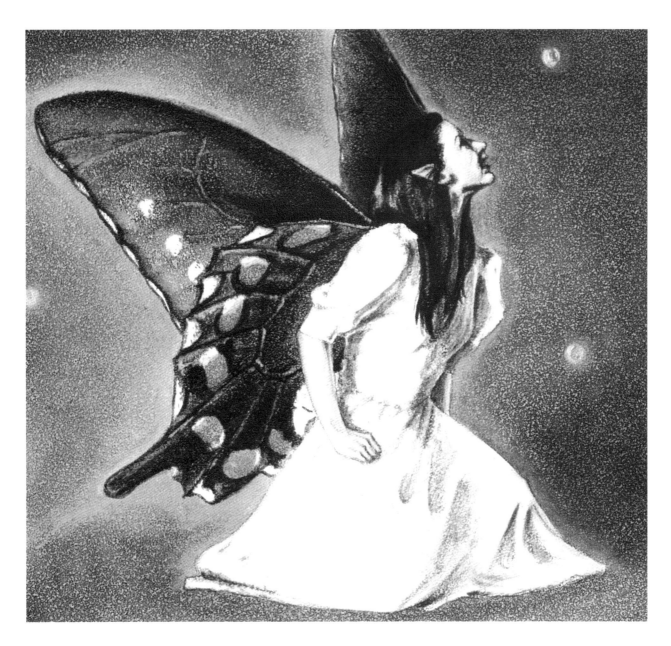

**ELVISH SPRITE GUIDE** (*ABOVE*)
5 x 7 in. Oil on board. 1995.

I did this piece for the trading card game, *Magic: the Gathering set, Alliances*. It was an early foray into oil painting, and apparently popular with a lot of the players (who liked fairy art). The model for this piece was a Seattle chanteuse who modelled a lot for me. – I think we did so many photoshoots that I used her for several fairy pieces.

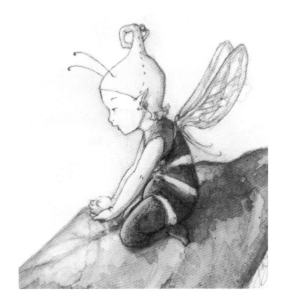

**BUMBLEBOY** (*RIGHT*)
2 x 2 in. Gouache. 1997.

Painted for a group Holiday Show at Baas Gallery in Seattle, Washington, USA. The size is quite small to give the feeling of a vignette. In retrospect it's very true to the children's illustration style of the 19th and 20th centuries, which is probably why it did so well at the show.

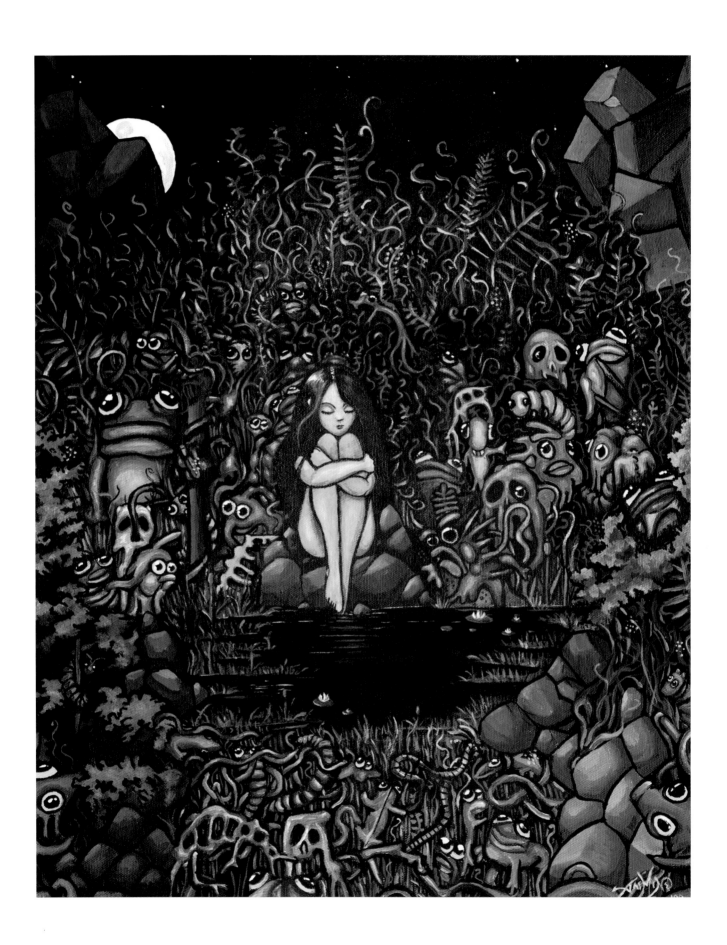

JASMINE BECKET-GRIFFITH

# JASMINE BECKET-GRIFFITH

*" My whole purpose in creating artwork stems from my general dissatisfaction with the mundane world. Painting my own little worlds. populated with my own people and my own ideas, I can add a little fantasy to my life, and to the lives of others. "*

Born in 1979 and raised in Kansas City, Missouri, Jasmine Becket-Griffith now lives in Celebration, Florida, where she follows her dream, spending most of her time painting, surrounded by her two cats, husband Matthew and fairy friends. She counts among her artistic influences Brian Froud, Mark Ryden, H.R. Giger, Larry Elmore, Hieronymus Bosch, Trevor Brown, Albrecht Dürer, Leonardo da Vinci, the Pre-Raphaelites and Asian sources that range from Hindu devotional imagery and Chinese landscape painting to contemporary Japanese pop culture. Creative boosts come from travelling extensively, spending time outdoors, taking photographs for later reference and reading dozens of art and art-history books – and from her extensive music library.

She works in acrylics, usually on unstretched canvas sheets, although occasionally she enjoys using thinned acrylics on moistened watercolour paper: "I find the organic swirls to be quite delicate and mystical-looking." She is currently experimenting with digital art, although as yet only for occasional graphic design rather than with any serious artistic intent. She often works with a limited palette, tending towards the darker colours: "They have a sombre, Gothic feel."

Jasmine has been commissioned for book covers, role-playing games, design, illustration, custom paintings, portraits and graphic design. Her website is at www.strangeling.com.

THOUGHTFUL FAIRY (*RIGHT*)
8 x 10 in. Acrylic on Watercolour paper. 2002.

This piece is one of a series of "Thoughtful Fairies". I sometimes enjoy experimenting with organic free-form backgrounds. I first started painting by dropping thinned acrylic paints onto pre-moistened paper, and then used some of the same basic colours in the fairy to bring the piece together.

WOOD NYMPH (*FACING PAGE*)
16 x 20 in. Acrylic painting on canvas. 1999.

There is no real perspective to the setting of this painting, and the lighting is very subjective. I think that gives it a very surreal, almost dreamlike quality. I began with the central figure and worked outwards, adding bizarre frog-like animals, all with staring eyes. Some people find it to be an ominous piece, while others find it cosy and reassuring.

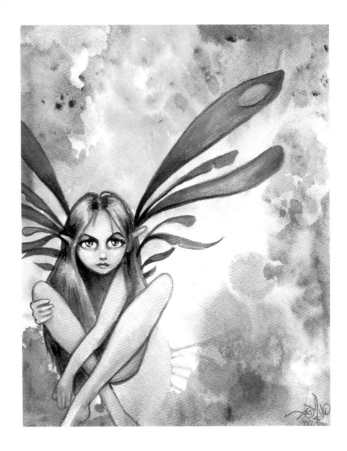

# LINDA BIGGS

" *I paint fairies how I see them, and how I want you to see them too. I love to tease the imagination so that some viewers see my fairies as sweet and innocent while others see them as voluptuous and sensual.* "

Linda Biggs graduated from high school in Baltimore, Maryland, in 1980 and, though she had no formal art training, went straight into graphics, advertising and printing. Eventually she realized painting was her life's passion and the only thing that could relax her; that was when she left her lucrative advertising career.

She tried different media – acrylics and oils – but eventually settled on watercolours. "I love Holbein watercolours in tubes, and work using Fabriano Uno cold-press 300lb art paper. Greens and blues – that's how I see everything, though lots of my works have a rainbow of colours in them somewhere. I enjoy painting on overcast and rainy days, but I don't limit myself to that."

A painting can take her up to six weeks to complete. She is influenced by her Cherokee spirituality and by the work of Maxfield Parrish and Georgia O'Keeffe. She finds commissions restrictive, preferring to paint what is in her head. The resulting works are in great demand. Visit her website at www.fairieforest.com.

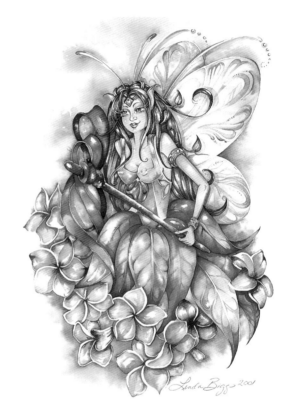

CHANTEL'S GARDEN (*ABOVE*)
10 x 15 in. Watercolour. 2001.

The plumeria is a tropical flower, and is one of my favourites. This Fae represents a beautiful fairie princess emerging out of this tropical plant. Her eyes have a twinkle that capture your attention.

LILY PRINCESS (*FACING PAGE*)
14 x 17 in. Watercolour. 2001.

When I was a young child, we had a garden with Lily of the valley around our front porch. I would see them bloom every spring, going out each day in the early morning to watch their progress. This painting is what I used to imagine while I watched them bloom.

FAIRIE DREAMS (*LEFT*)
14 ½ x 17 in. Watercolour. 2000.

*Fairie Dreams* came to me when one of my orchids blossomed. The purples were so pretty on the Vanda (a type of orchid) that I kept imagining the flower with a tiny peaceful fae sleeping under it.

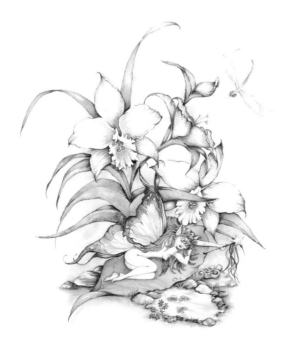

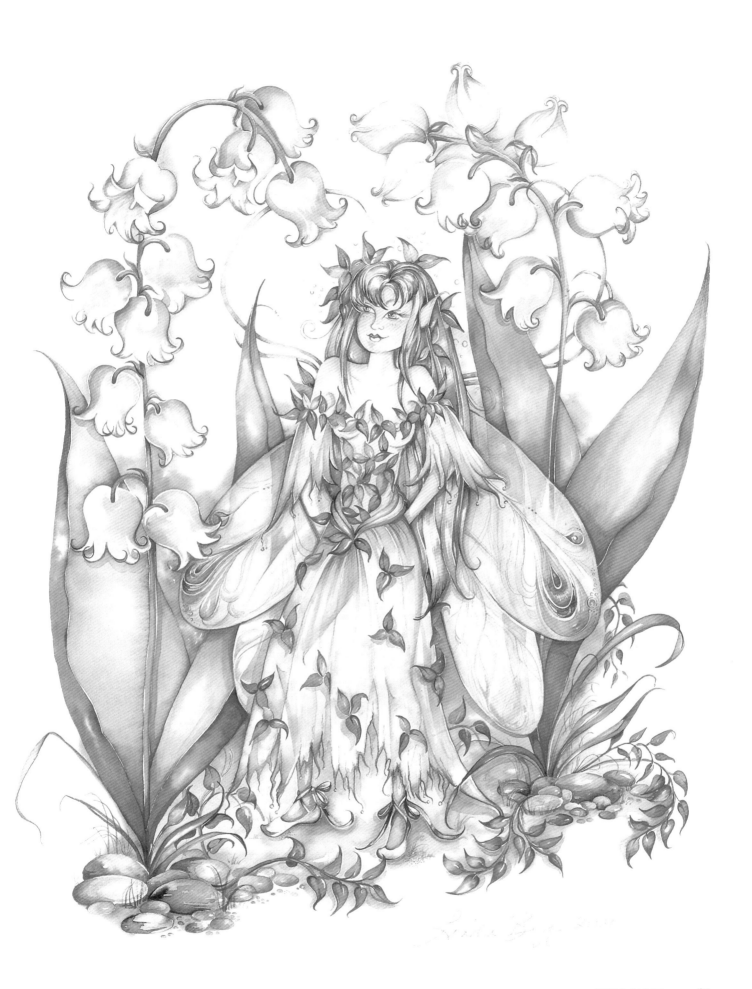

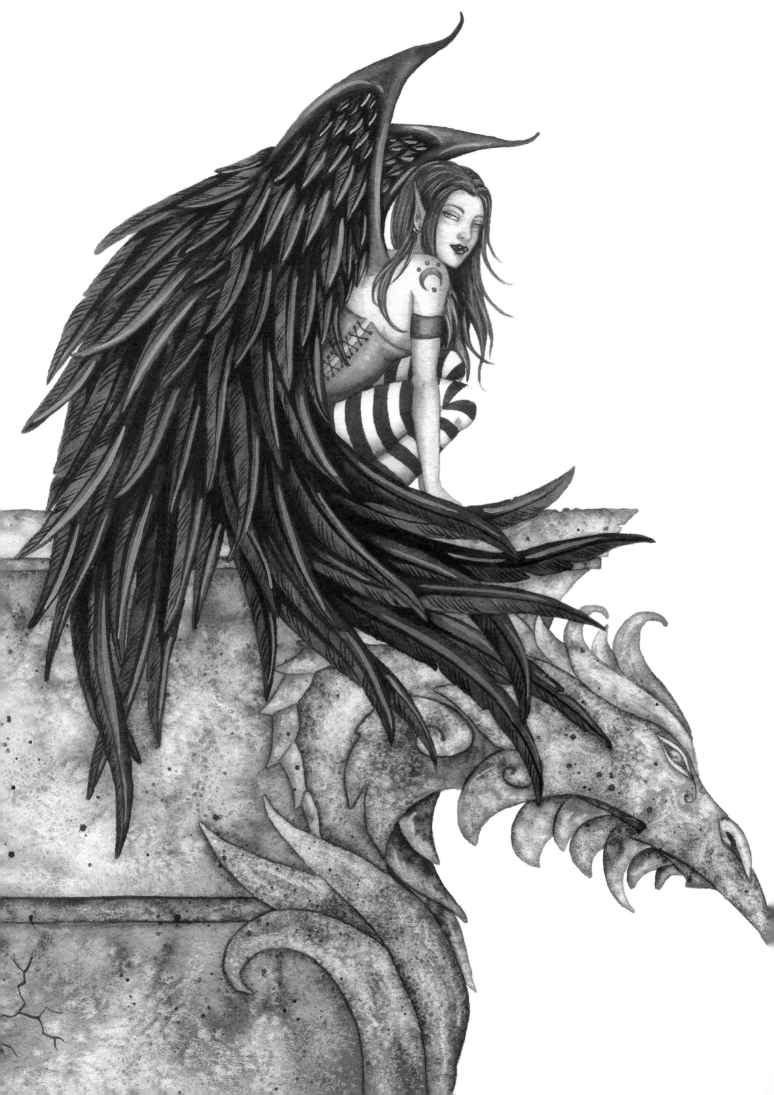

# AMY BROWN

" *Sometimes I get frustrated because I have so many ideas fighting to come out. Every painting has so many possibilities.* "

Amy Brown is without a doubt one of the most talented fantasy artists in the world today. She was born in Bellingham, Washington State, in 1972, and began drawing at a very young age. For Amy, the decision to become an artist was not consciously made; she recalls that from earliest childhood she always simply assumed she was going to be one, as if she had no choice in the matter. The pattern continues to this day: "Often there are days when I really don't *want* to paint – I just *have* to paint. The urge to create is almost a wild, living entity trapped inside me, clawing to escape and leave its mark on the world."

Even so, throughout her childhood and teen years she didn't take her art particularly seriously. In 1992, aged 20, she got a job working as a custom picture framer at a local gallery. She stayed in this job for over seven years, and now reckons it was the best training she could have had for her eventual career. "I was exposed to a wide range of art in all media. Working with matt boards and frames gave me a good background for colour, texture and design."

A few months after she'd started working at the gallery, her boss handed her an empty frame and told her she should try painting a picture in it

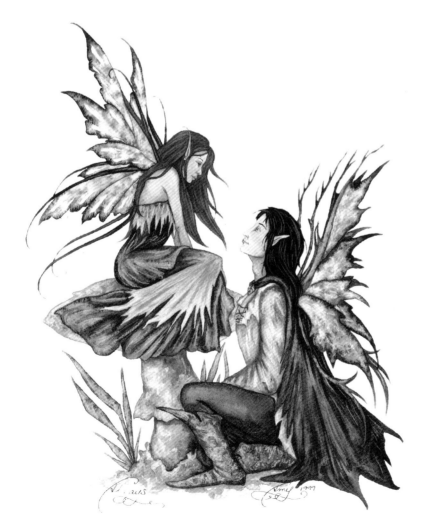

ALWAYS (*LEFT*)
11 x 14 in. Watercolour. 1999.

I believe I may have been in rather a mushy mood while working on *Always*. For some reason, during approximately a month long period, I painted several romantic pieces.

GOTHIC (*FACING PAGE*)
11 x 17 in. Watercolour. 2002.

*Gothic* was an experiment. I wanted to see how a predominantly monochromatic painting with just a touch of colour would turn out. I was fairly pleased with the end result.

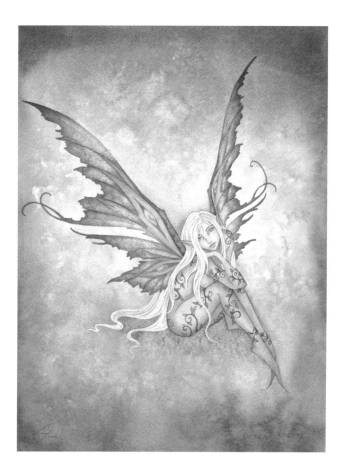

GREEN SPRITE *(ABOVE)*
9 x 12 in. Watercolour. 2002.

*Green Sprite* was created when I realized I hadn't painted
any green faeries in at least a couple of years. One must
never go too long between painting green faeries.

MOONSPRITE *(FACING PAGE)*
11 x 14in. Watercolour. 2002.

I had the title for *Moonsprite* banging around in my head
for several months before I got around to developing an
image to go with it. Often the title comes to me long before
the painting does.

– "Maybe a little fairy or something?" he said.
She'd been interested in fairies ever since, a few
years earlier, an aunt had given her a copy of the
book *Faeries* (1978) by Brian Froud and Alan Lee,
but she'd never thought to draw or paint one.
That night she painted a fairy hovering next to a
clump of foxgloves. When the finished piece was
put on show in the gallery it sold within a few days
. . . and her career as an artist of Faery had begun.

In 1993 she started testing the market for
prints of her fairy paintings. At first these were
only laser prints – she could run off a few at a time
without stretching her finances too much. She
sold these prints at street fairs, and a couple of
friends sold them through the shops they ran. A
year or two later her boyfriend – now her husband
– created a website for her. That first site had a
single gallery with about ten pieces in it;
nowadays it has multiple galleries and nearly 150
images on display.

Her major influences have been Brian Froud
and Michael Parkes, and she believes this shows in
her paintings – although others might regard her
as a true original. She has also been greatly
inspired by the urban fantasies of writer Charles
de Lint and the haunting, ethereal music of
Loreena McKennitt.

> " *Ultimately, I want each painting to
> evoke a deep emotion in the viewer –
> hopefully a longing to become a part
> of the painting itself.* "

When she begins a piece she usually just starts
with a blank sheet of paper and draws. The initial
drawing phase can take her anything from fifteen
minutes to days, months or even years. The pencil
drawing completed, she begins laying down the
background colours. She paints with Daniel Smith
Extra Fine watercolours and Winsor & Newton
brushes, and usually on 140lb or 300lb Arches
cold-press watercolour paper; "The texture of
Arches seems the most conducive to the mix of
textures I like to use when painting."

Her images are sold worldwide as cards,
prints and calendars, and the wide range of
licensed items based on her work includes
figurines, journals, stickers, jewellery and even
lunchboxes. She does not accept commissions,
however, preferring to paint her own ideas. Visit
Amy's site at www.amybrownart.com.

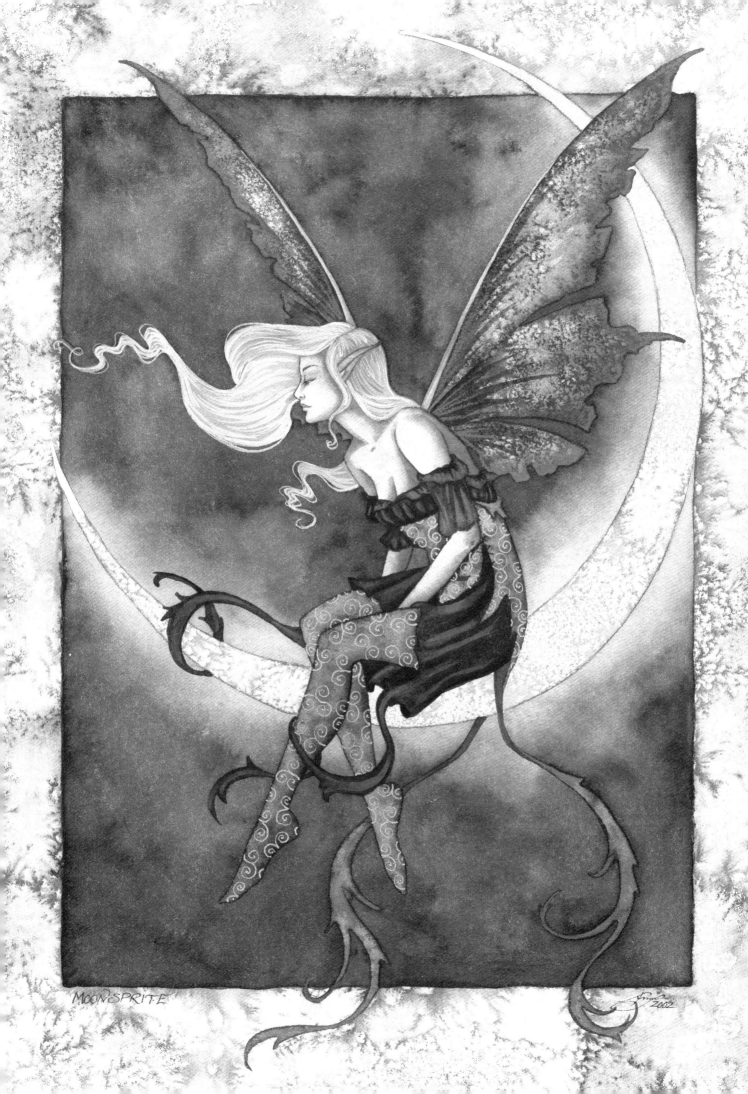

MOON SPRITE

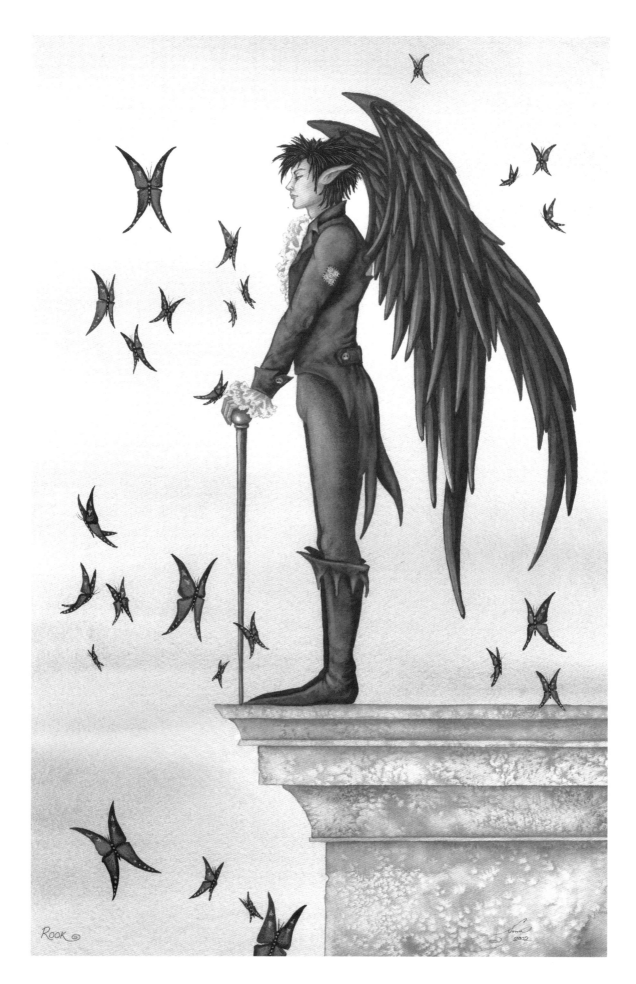

Rook

ROOK (*FACING PAGE*)
11 x 17 in. Watercolour. 2002.

*Rook* started out as a doodle I was doing while watching TV one evening. I liked the way he turned out and decided to paint him. He's a part of a series of winged "bad boys" I've been working on for the last few years.

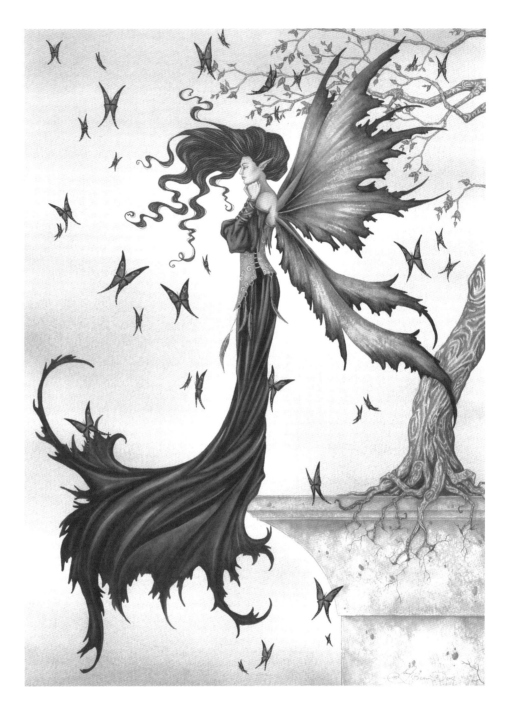

MYSTIQUE (*RIGHT*)
18 x 26 in. Watercolour. 2002.

*Mystique* is perhaps one of my favourite paintings. I'm drawn to the mystery and beauty portrayed by the faery woman and the multitude of dark butterflies surrounding her. The tree growing out of the marble symbolizes the strength of nature.

" *My favourite images are always the ones I can look back on and say, 'I wouldn't change a thing.' Ironically, these are rarely the images best received by the public. Quite the reverse: if I hate it, everyone else thinks it's great!* "

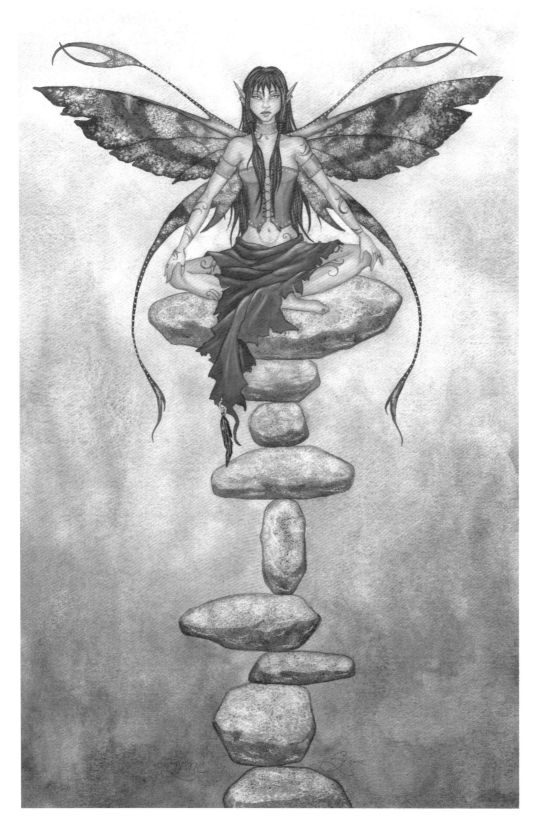

MYSTIC *(LEFT)*
11 x 17 in. Watercolour.
2002.

In *Mystic*, I wanted to portray a sense of spiritual power. The faery is a shaman, meditating on her precarious perch. She is calm, sure of herself, and in complete harmony with her surroundings.

LIGHTING THE WAY
*(FACING PAGE)*
8½ x 11 in. Watercolour.
2001.

This angel guides lost souls, prayers, hopes and dreams to the heavens.

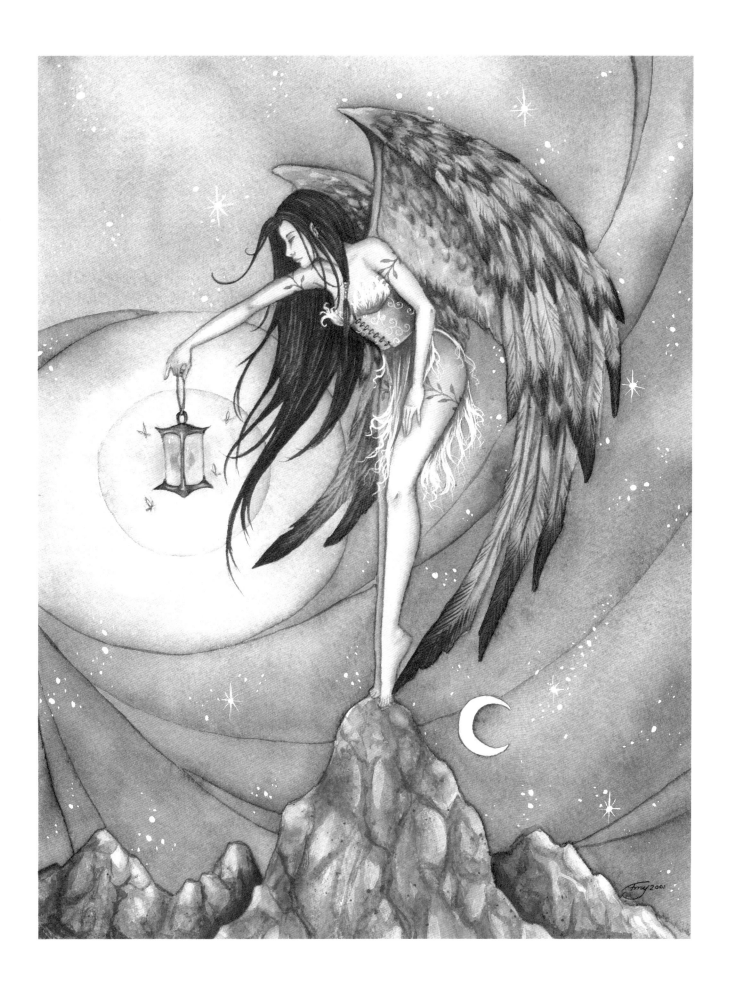

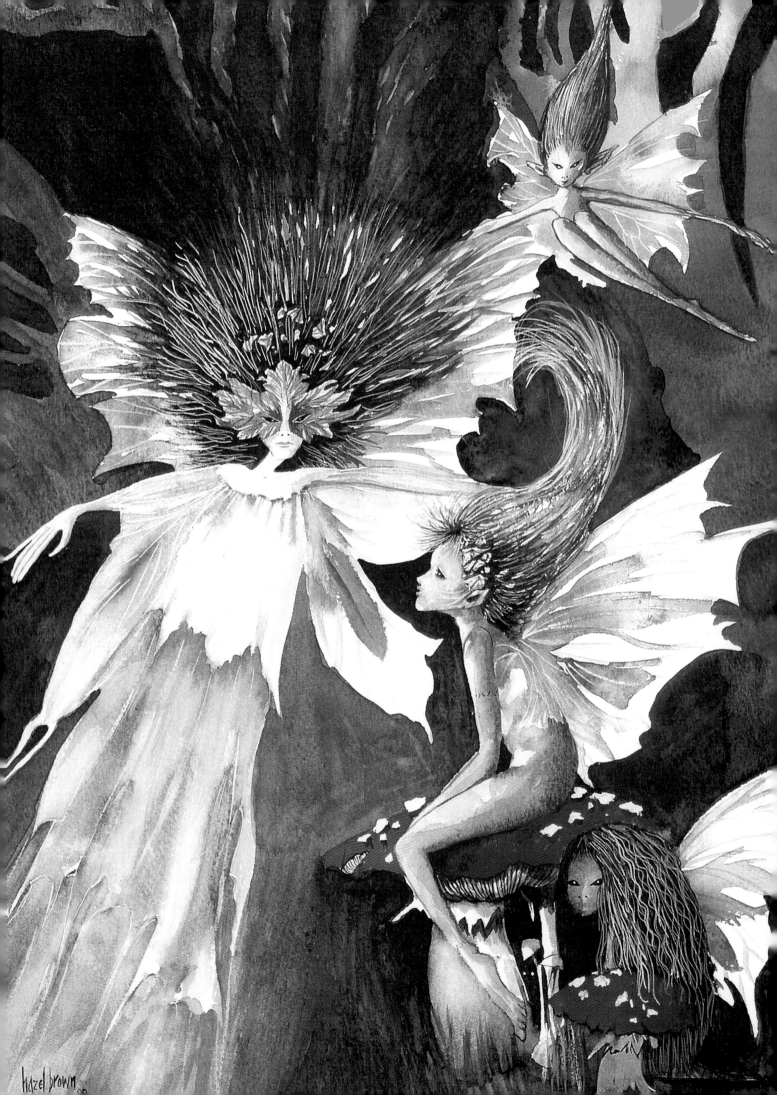

hazel brown

# HAZEL BROWN

*" I have always been drawn to nature, and am constantly aware
of weather, wildness and the glorious freedom to explore.
I become hypnotized by its immensity. "*

Hazel Brown was born in London, but in early childhood moved to Devon, in southwest England. Living close to the sea provided an enormous stimulus to her imagination, as did exploring woods and trees, fields and hedgerows; there she found hideaway places, and soon realized she was opening up to the world of Faery. Thus began a lifelong relationship with "all those elemental beings who inhabit the wilder places of nature". She recalls that when she first encountered the fairies they appeared to her as "tiny specks of light with movement on a strand of infinitesimally fine energy". Hazel could therefore be described as a visionary artist; her perceptions of fairies are a part of this connection to nature that she has felt since childhood.

IN THE SHADOW OF TWILIGHT (*FACING PAGE*)
20½ x 11¼ in. Watercolour and inks. 1999.

This is the most enchanted time of the day. Faeries may appear at the edges of twilight, when daylight moves slowly into dusk. If we keep our "inner senses" alert this can be the perfect moment to see faeries, when time shifts and the Hidden Kingdom is revealed.

GREENMAN (*BELOW*)
20½ x 11¼ in. Watercolour, ink and pencil. 1999.

For most of my life I have felt a strong connection with "The Greenman" enabling me to become attuned to the essential spirit of nature. His wild vitality connects me to all those elemental forces of Faerie – he has a special place in my paintings and in my heart.

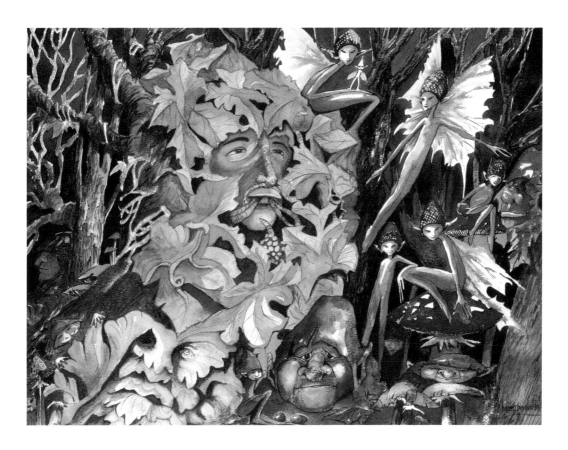

**CRANESBILL FAERIE** *(ABOVE)*
14 x 10 in. Watercolour. 2002.

Elegant and aloof, this elemental emerged from the vibrant energy of the little cranesbill flowers found in a hedge on a walk one afternoon in the summer. A feeling of constancy and something eternal emanated from this tiny flower.

**BUTTERFLY FAERIES** *(RIGHT)*
9 x 13½ in. Watercolour. 1980.

This was one of my early paintings of faeries, completed in the summer. A peek into the microscopic world of butterflies brought these tiny elementals into my inner vision. I attempt, however clumsily, to paint as closely as possible, just what I "see".

OBERON AND TITANIA *(Right)*
11½ x 8¼ in. Pen and ink. 1991.

I have always been a strong believer in the Celtic faith and have been greatly inspired by their artwork and philosophy. I did this drawing in black and white to emphasize the clarity of vision that has come to me through my connection with, not only the Celts, but also the long traditions of Faerie.

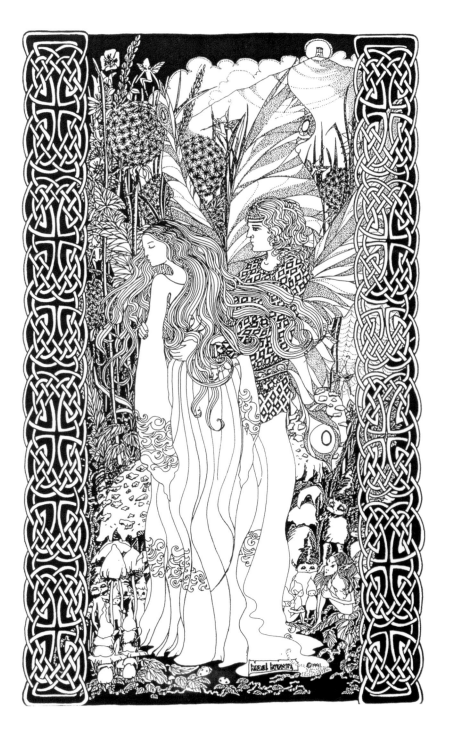

*" Letting my hand draw freely, a tapestry of creatures will emerge: elves, goblins, fairies and pixies, and also characters I've never encountered before, weaving their way into the drawing. They peep from behind lichen-covered boulders or sit squarely on old toadstools, staring out at me from the page. "*

Drawing came naturally to Hazel as a child, and she covered the insides of her books with pictures whenever she ran out of other paper. Her favourite childhood book was an edition of *Hans Andersen's Fairy Tales* illustrated by Harry Clarke. She pored over it for hours, she remembers, and its plain pages were not immune from her drawn contributions. It wasn't until years later that she discovered the illustrations of artists like Arthur Rackham, Edmund Dulac, Richard Dadd, Alan Lee and Brian Froud. She was inspired also by the poetry of John Clare, W.B. Yeats and Christina Rossetti, and the novels and stories of Alan Garner, Susan Cooper, Terri Windling and Robert Holdstock.

Her first love is watercolours, but she is not averse to using other media when a piece calls for it: acrylics, inks, pencil and wash, gouache and so on. Her primary technique involves the use of watercolour washes over preliminary drawing work done on handmade acid-free paper. She tends to use fairly muted colours, mainly reflecting those found in nature.

Her drawing usually starts with whatever vision she may have received that day. She is

TOADSTOOLS (*ABOVE*)
20½ x 11¼ in. Pencil drawing. 2000.

Once, when stepping over a group of toadstools on a woodland path, I was instantly reminded of a gathering of little old Goblin men "telling the tale" – but was it wisdom or gossip that they exchanged? Then I noticed a few other characters beginning to appear, a couple of curious faeries, an elf and an aged tree-dweller!

usually aware initially of a shape, or even of a pair of eyes staring back out at her from the blank page. She lets her pencil move freely, so that the drawing just seems to flow out until the paper is covered with "a myriad of creatures all trying to outdo each other for the best position". Hazel works intuitively, and feels guided by the fairies themselves – "and not always by sweet winged beings. Old gnarled oak-men often appear on the page, as do elves, dryads, boggarts, pixies and creatures in many shapes and guises. Some seem to want to be in every painting – the first on the page!" She says that she feels strongly guided by her fairy muse, "an old lady, a faerie godmother, who inhabits my world and my dreams". Hazel's work can be seen at www.faery-art.com.

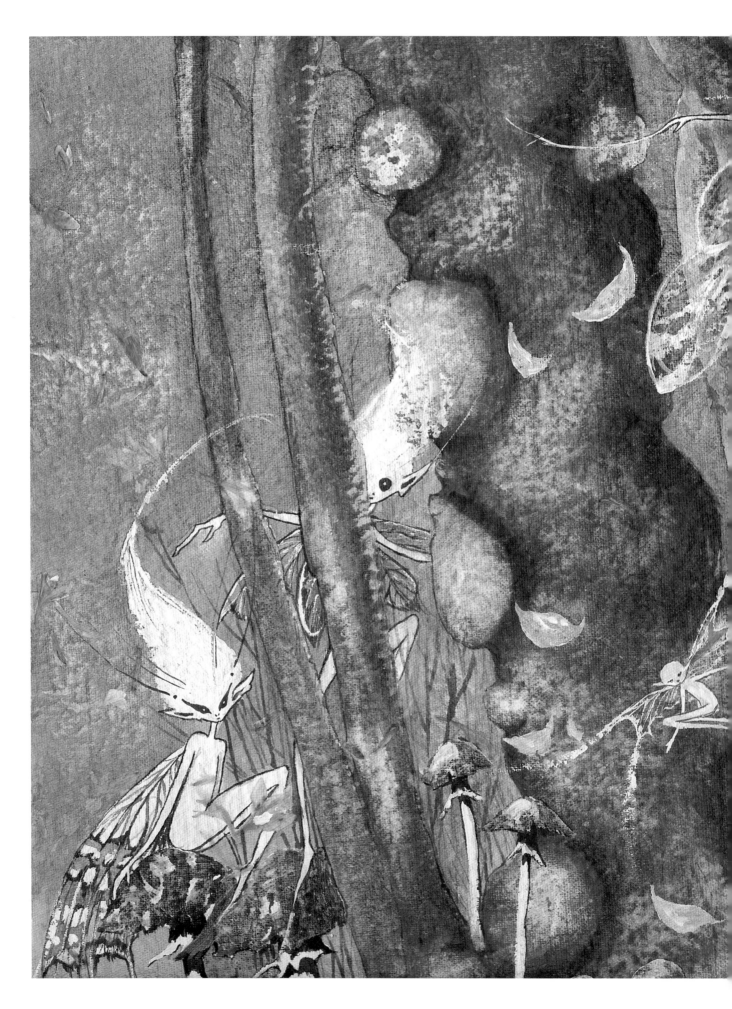

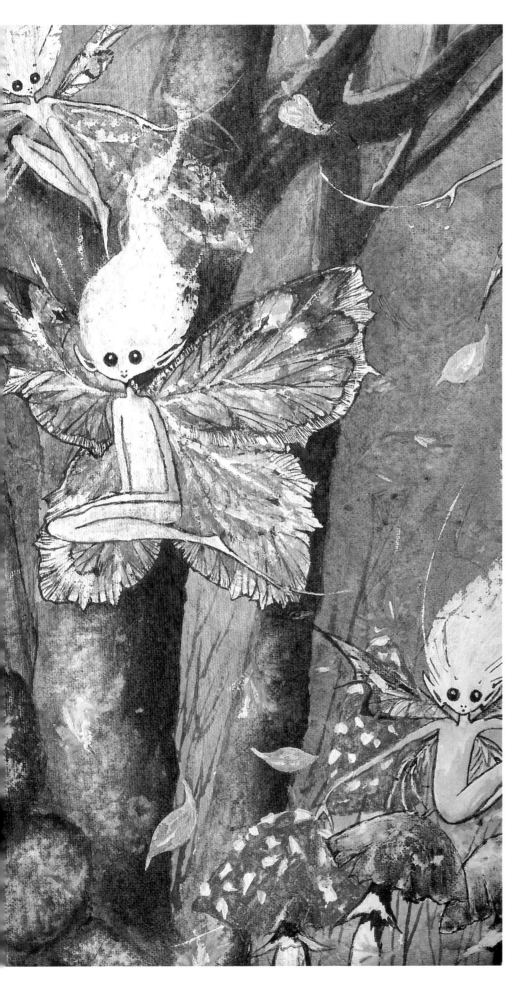

WOODNYMPHS *(LEFT)*
20½ x 11¾ in. Watercolour on
handmade paper pressed with
flowers. 1989.

These tiny creatures appeared quite
suddenly in a light swirl of mist,
flickering and tumbling like leaves,
spinning and whirling down from a
tangle of branches in an oak tree
above my head – then in a moment,
they were gone!

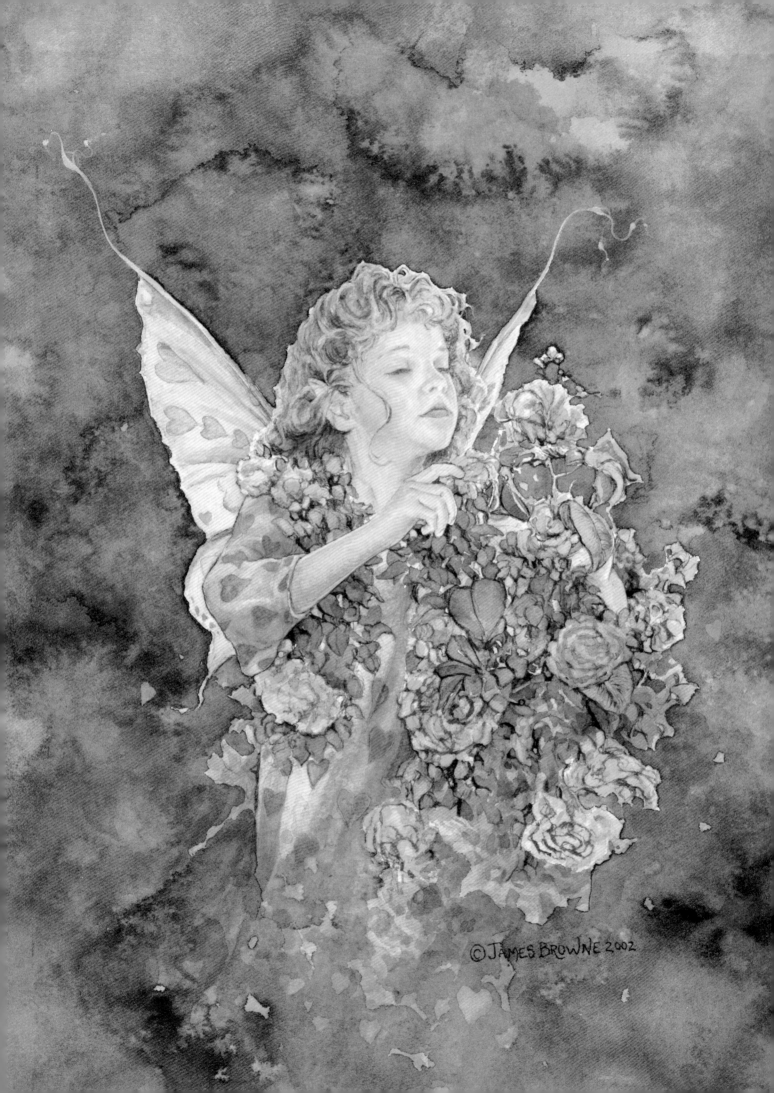

©James Browne 2002

# JAMES BROWNE

*" To say something about myself, apart from art, is hard to do.
I think about art all the time and I couldn't think of anything better to
do with my free time than to paint. "*

James Browne was born in Upper Bucks County, Pennsylvania, not far from Philadelphia, and grew up in the countryside. The family lived on top of a mountain that looked across the Delaware River – "It was a magical place where my imagination could grow." He and his two siblings explored streams and brooks, "hundreds of gnarly trees" and all the other joys of nature, as well as covered bridges: "We even had a troll living nearby."

The family moved to the suburbs of Philadelphia in the early 1980s, and after high school – where he thought he was destined to become a sculptor – he enrolled at the University of the Arts in that city, graduating with a Bachelor of Fine Arts degree in 1993. He feels that what he learned of value at college was how to meet deadlines and how to stay awake during critique;

his work and his techniques being all his own. He and his wife Nadine now live in Phoenixville, Pennsylvania, spending two months of each year in Nadine's homeland, Germany.

James grew up learning how to draw by looking at the book *Faeries* (1978) by Brian Froud and Alan Lee, and he lists these two artists as among his main influences. Right at the top of the list, however, are Arthur Rackham and Alphonse Mucha. Others of importance are Maxfield Parrish, John William Waterhouse and N.C. Wyeth ("I practically live in his backyard, and so I view his work all the time").

Perhaps more importantly, he reckons that his imagination stems originally from his childhood. The family television set was kept on the top shelf of a closet, and so the children spent much of their time indoors with books. He can vividly

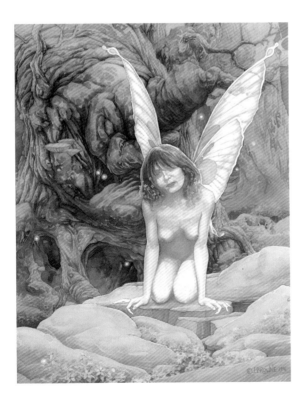

TWILIGHT *(LEFT)*
18 x 24 in. Watercolour. 1996.

I painted *Twilight* after viewing some of Parrish's original paintings at an exhibit in Stockbridge, Massachusetts, USA, back in 1996. I was really inspired by his sense of colour. The subject is one of rest, longing and pondering. Emotion in a painting is everything to me, and the emotions in this particular piece reflected an aspect of my life at that time; longing for love.

A'MOUR *(FACING PAGE)*
8½ x 11½ in. Watercolour. 2002.

Often seen around when love is in the air, A'mour, the Valentine Faery, takes her flight. Many times she glides through the air only to spot a loving couple walking side by side. It is her job to make sure they are walking hand in hand.

recall his mother's voice as she read to them C.S. Lewis's *The Chronicles of Narnia* and J.R.R. Tolkien's *The Lord of the Rings*, both of which still serve as triggers to his inspiration.

His mind is constantly full of images he'd like to create. When he has decided on one, he puts on some classical music, lights some pine incense and begins to draw, surrounded by any reference material he may have gathered. He tends to avoid thumbnails and paint studies: "I believe the more you rework a sketch or a painting the more likely you are to lose the emotion in the finished piece." When he's satisfied with the drawing he inks it in sepia, then paints very quickly, keen to keep the emotion fresh. He often has five or ten paintings on the go at any one time, finishing them as the mood comes to him.

Browne has illustrated two children's books so far: *Bartholomew's Blunder* (1998), written by Anna Pennington, and *Into Enchanted Woods* (2001), written by Jennifer Bryant. Of the latter he recalls that "I had a wonderful time working on it. I was able to have full creative freedom (every artist's dream) while creating the illustrations, and completed the whole project in just two months." He hopes one day to write and illustrate his own books. In the meantime he sells prints and originals of his wryly idiosyncratic fairy paintings from his website, www.jamesbrowne.net.

GIVEN TO FLY *(RIGHT)*
11 x 14 in. Watercolour. 1999.

I feel this painting best describes a child's imagination. As in most of my work, I often like to pull the real and the fantasy worlds together. I used to catch fireflies and other creatures when I was a small boy. But like most things in life, there is always a time we must let go.

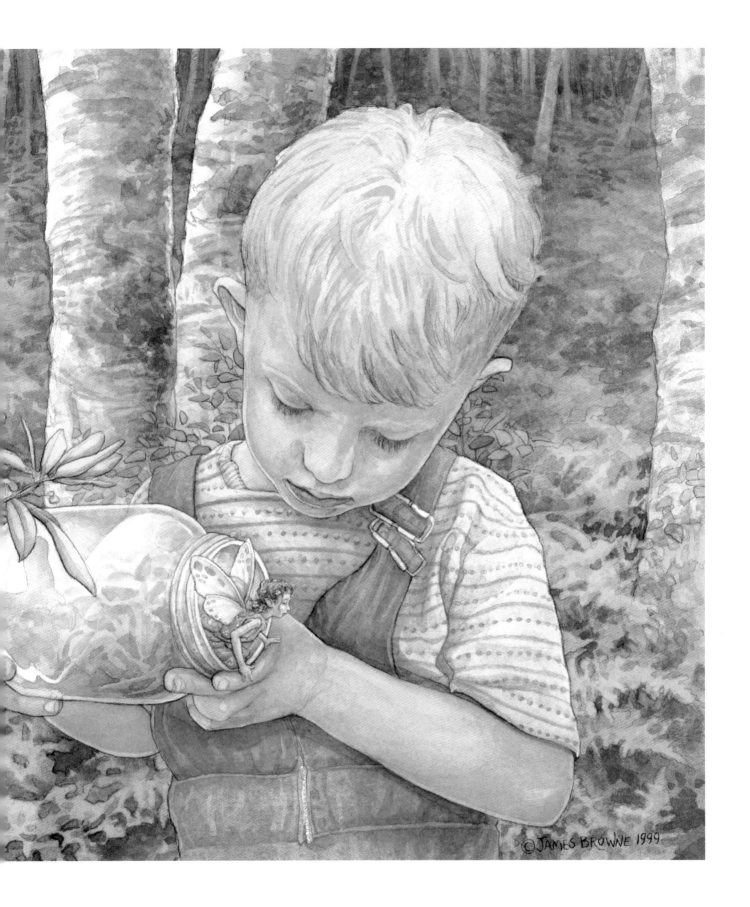

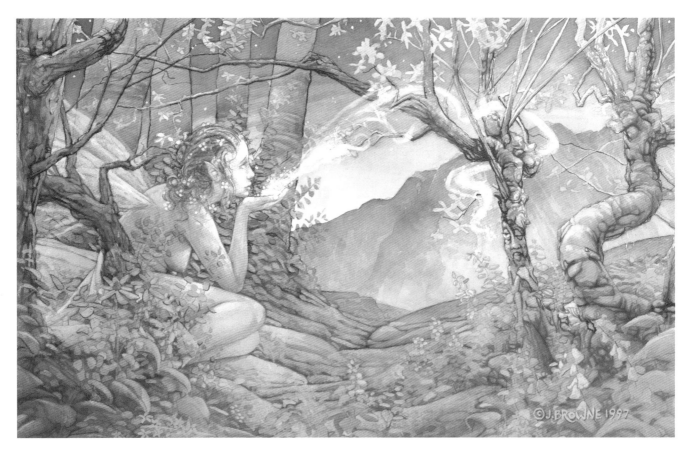

DAWN *(ABOVE)*
12 x 18 in. Watercolour. 1997.

I believe that every faery has a purpose. The Dawn faery always awakens sleeping tree spirits and other magical creatures. I painted this after reading *A Midsummer Night's Dream*.

> *" I want to leave behind a body of work that will live on forever. I want to touch as many people as I can with the imagery I create and bring out the child in all who view my paintings. "*

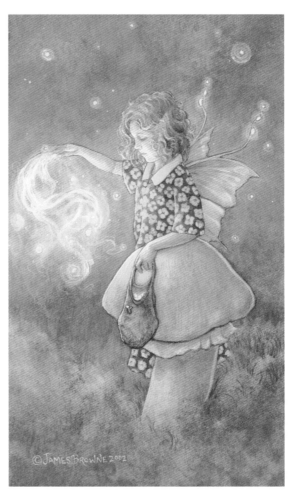

FAIRY DUST *(RIGHT)*
4 x 8 in. Watercolour. 2002.

These beautiful creatures can sometimes be seen spreading their faery dust. One never knows what kind of spell it casts, until coming in contact with this magical dust.

## Salutations *(Above)*
6 x 10 in. Watercolour. 2000.

Faeries can often be found in conversation with insects. They seem to share a lot of the same perspectives in life. While on one of my trips to Germany, I created this piece while being greatly inspired by one of my favourite artists, Alphonse Mucha. Though his subject matter is different, I am in awe of his sense of design.

## High Point *(Left)*
11 x 17 in. Watercolour. 1999.

This is a painting I did of my muse and wife, Nadine. I'm always inspired by our walks through the woods. Smelling the fresh air and gazing up at the trees, we often run into fairies there. I created this painting to capture the moment.

RAINBOW FAIRY *(Facing page)*
5½ x 8½ in. Watercolour. 2002.

A faery of all elements, the Rainbow Faery shows her graceful beauty. I enjoyed the challenge of working all the colours of the rainbow into this image. The real challenge was to keep her ethereal.

LIGHT DUSTER *(Above)*
6 x 6 in. Watercolour. 1999.

I came across this little fae while I was barbecuing in our garden one summer night.

FIRST KISS *(Right)*
8½ x 11½ in. Watercolour. 2002.

I discovered quite a surprise when sorting through the boxes of ornaments and Christmas lights while getting ready for the holidays. I happened upon a little brown box that was moving all by itself ... or so I thought. Being the curious individual that I am, I picked up the box and opened it up. This is what I saw.

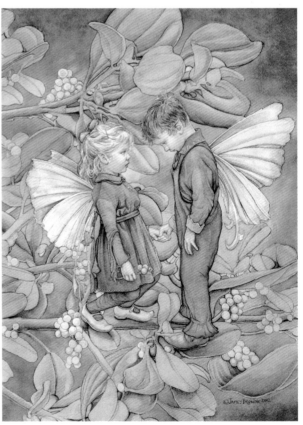

# JACQUELINE COLLEN-TARROLLY

*" I'd hear the soughing in the trees and almost always catch the hidden words being sung within it. I'd see faces in trees and flowers and clouds. I've just always been very aware of other life around me. "*

Born in Colorado in 1968, Jacqueline Collen-Tarrolly became hooked on fantasy at the age of about ten. Today she counts among her influences movies like *Labyrinth* (1986) and *Legend* (1985) and artists like Sir Lawrence Alma-Tadema, John William Waterhouse and Brian Froud. Music is another source of inspiration: "I'll sit down with a creative idea and a feeling to convey, and I need music for that mood."

Jacqueline uses acrylics (usually thinned with water), heavyweight watercolour paper and a variety of brushes and other tools, such as sponges and her fingers – whatever brings the desired effect. Occasionally she uses coloured pens for fine lines, but generally finds she does better linework freehand with a brush. She starts with a simple sketch, next adds detail directly with paint for the background, then does the main figures before finally fleshing out the background. She often uses rubbing alcohol to wipe out areas of paint to give such effects as sunlight filtering through forest trees. Visit her website at www.toadstoolfarmart.com.

GOTHICA *(RIGHT)*
11 x 17 in. Acrylic paint. 2002.

I intended to give this fairy black hair, but when I was working on her I kept putting it off, and finally when all else was done, I realized why: she wanted to have white hair. The contrast to me is wonderful – it gives the fairy a sense of innocence even in the midst of all this darkness.

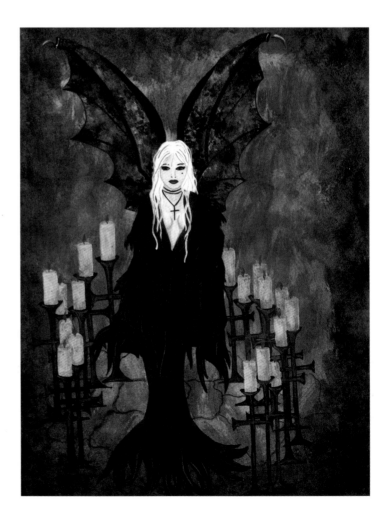

HANGING THE MOON *(FACING PAGE)*
11 x 17 in. Acrylic. 2001.

There is something about the saying, "Hanging the moon on a star" that conjures up such dreams for me – I wanted this piece to have the feeling of etherealness and endless possibility that such a saying invokes.

 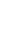

# DAVID DELAMARE

" *My interest in faeries is an interest in the exotic, and in particular places in time. I think of them as being part of the landscape of Victorian England, the plays of Shakespeare, the life of Conan Doyle, and the poetry of Edmund Spenser.* "

David Delamare's favourite photograph of himself shows him at the age of five dressed in full cowboy regalia – pistols drawn to threaten the photographer (probably his mother). The distinguishing feature of the photo is that he's not wearing trousers, just white cotton underpants. "I think," he explains, "the image suggests that, if I wasn't going to be an artist harbouring a particular perspective, at least I would be a person of dubious intention."

David was born in Leicester, England, but the family moved to the USA when he was just three. As a child he spent many happy afternoons dressing in elaborate costumes or creating fanciful picture books. Years later, his paintings are a natural extension of that original pursuit of the strange and the whimsical. He is particularly inspired by subjects and settings that suggest something magical or dramatic stirring just beneath the surface. While he has only recently begun painting fairies, he has always been drawn to the worlds they inhabit.

Fairies fit Delamare's predilection for all things English, particularly the England of literature. He is an avid fan of Shakespeare, Doyle, and Dickens and in his daily American life, cleaves to what he considers to be English preferences and sensibilities: "emotional coolness, an affinity for artifice, privacy, the fostering of eccentricity, theatricality, grey weather

and dark beer". Family members have also influenced his artistic development. His mother, Una, has been a lifelong source of encouragement and remains his biggest fan, while his grandmother, Ida, provided direct artistic inspiration. He recalls, "Ida was a vaudevillian who performed an act called Legmania. In her last few years she lived with my mother in Portland, Oregon. On many evenings, against her doctor's orders, we would nurse a bottle of brandy and smoke Player's cigarettes while she told me stories of her days on the Circuit. I think these

A LITTLE NIGHT MUSIC *(FACING PAGE)*
18 x 24 in. Oil and acrylic. 2002.

If I could only take the music of one single composer to a desert island, it would be Mozart's. This painting is a small acknowledgement to him.

PATIENCE *(ABOVE)*
12 x 16¼ in. Acrylic. 2002.

This is a preliminary acrylic version of a concept I later rendered in oil in a circular format. The new version will be part of an upcoming book dealing with the topic of unusual vices.

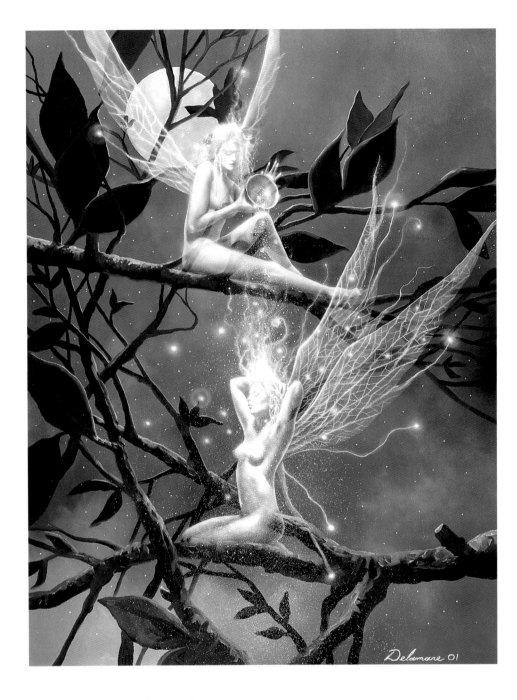

This painting extols the virtues
and rejuvenating power of
bathing in star dust. This is the
fairy counterpart to my mermaid
painting, *Bathing In Moonlight*.

" *When painting, I don't want to be overly focused.*
*There's a famous anecdote regarding Goethe.*
*When writing, he kept a box of rotting fruit by his desk.*
*This distracted him enough to allow interplay between the*
*conscious and the subconscious.* "

ELIANDOR *(RIGHT)*
12 x 16¾ in. Acrylic. 2002.

More often than not, I use models; for this piece I did not, it simply blossomed out of my imagination. These imagined faces sometimes inspire letters, often from the other side of the world, pronouncing with incredulity: "You have captured my likeness perfectly."

memories form the back-drop for a general theatricality in my work, and probably a specific inspiration for my last book, *Animerotics: A Forbidden Cabaret* (2001), which was dedicated to her."

Of course inclination, support, and even skill amount to little without ideas. Fortunately, Delamare is "a passionate observer". The catalyst for a painting is often something quite small and ordinary: a certain shadow, the sound of glass breaking, a half-heard phrase in a restaurant, or the whistle of a passing train. Once an idea has taken hold, the art comes quickly. He finds artistic stimulation in theatre, music and film; in fact, he seldom paints without music, an audio-book or a movie in the background.

Typically, he begins with small sketches, then employs models. Because he favours dramatic lighting and demanding poses, he works from photographs. These in hand, he begins translating the composition in pencil to canvas or mounted watercolour paper. He then works with oil paints or transparent acrylic inks; if using both, he often applies the acrylics with an airbrush, then paints over them in oils with a traditional brush.

In addition to creating paintings for galleries, he has completed ten illustrated books. His next, *The Mermaid's Tale* (2004), written by his agent Wendy Ice (co-author of *Animerotics*) will feature over 150 illustrations. His paintings and licensed products may be viewed on his official website: www.daviddelamare.com.

THE LOOKING GLASS FAIRY *(Above)*
12 x 16¾ in. Acrylic. 2002.

This is one of a series of sepia or brown-toned
paintings in which the image extends beyond
the frame in a calculatedly decorative manner.
This method was used to great effect by the
20th-century artist, Alphonse Mucha.

LITTLE WINGS *(Facing Page)*
18 x 24 in. Acrylic. 2001.

This piece was inspired by the notion that in any
given system creatures must have an occupation.
This fairy acts as a steward for orphaned eggs,
watching over them until they hatch.

"*If we're constantly in a state of wonder, it is more
likely we will be receptive to those little cues that can be
plucked out of the ether.*"

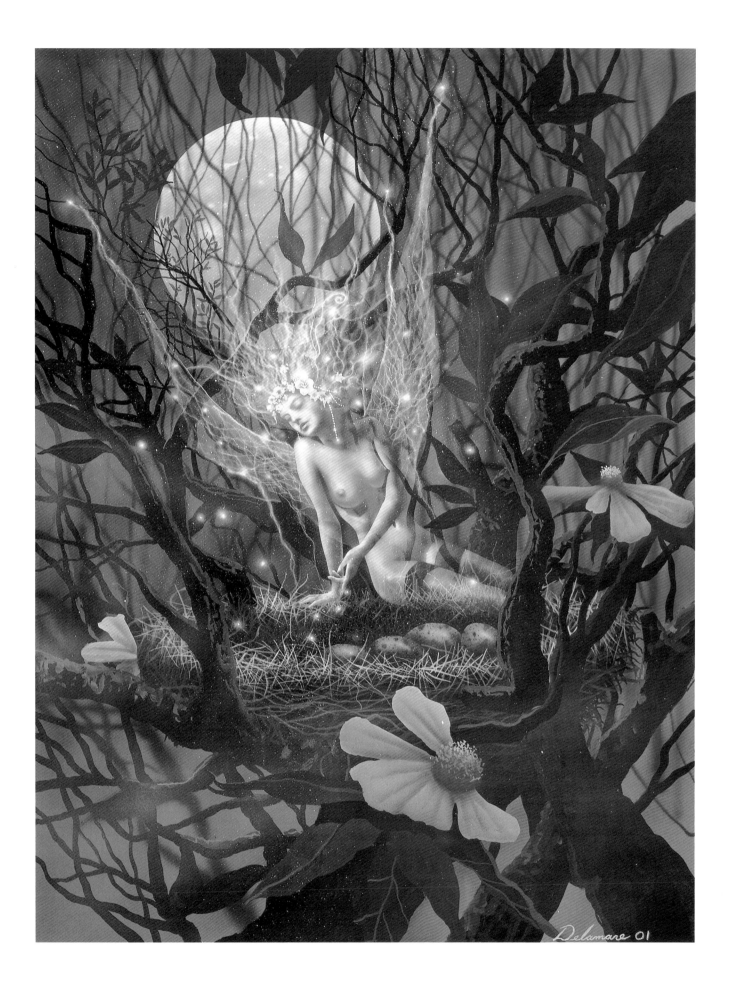

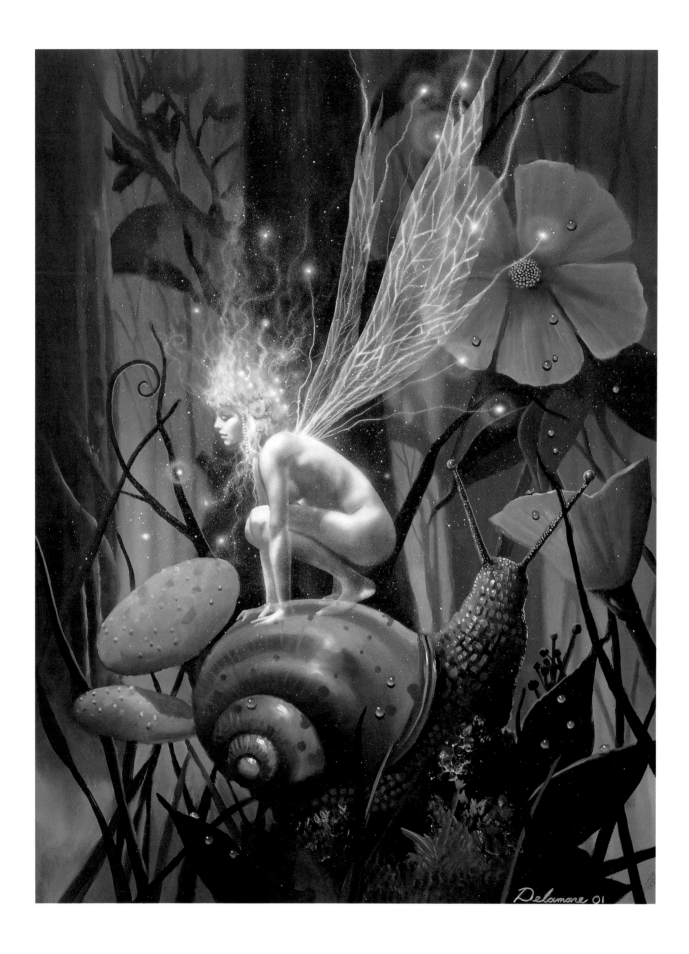

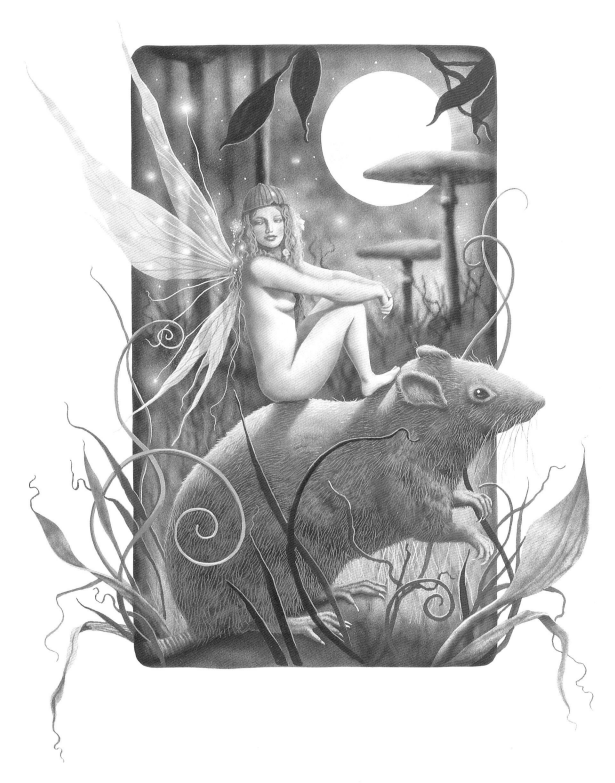

THE DEEP WOOD (*FACING PAGE*)
18 x 24 in. Oil and acrylic. 2001.

I like the formality of this figure; it reminds me of a
piece of statuary on a very exotic base. I find snails quite
beautiful, and the opportunity to paint one up-close was
very appealing.

IDA AND ELOUISE (*ABOVE*)
12 x 16¾ in. Acrylic. 2002.

I've always been attracted to images of conveyance.
Given fairies' winged mobility, mouse transport would
appear highly impractical. I think the nature of this pair's
relationship is mysteriously symbiotic.

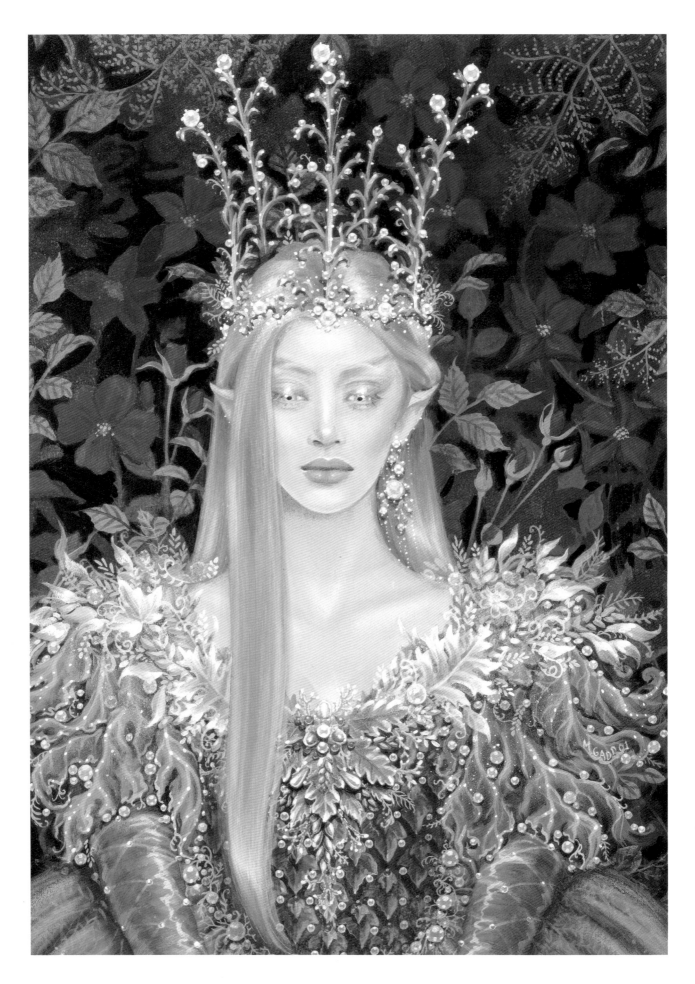

# MAXINE GADD

*" I can be struck by a vision that comes like a bolt out of the blue.
I then begin to draw. It's like an explosion. The sketches I do are very
crude – full of expression and energy. "*

Born in Worcestershire, England, in 1962, Maxine Gadd now lives in Western Australia. From the age of three she seems to have been interested in little else but drawing. She attended drawing classes at college, but is essentially self-taught. She is inspired in her art by music – Kate Bush, Tori Amos, Steely Dan and Loreena McKennitt as well as tango, jazz and classical – and by reading: Christina Rossetti, Oscar Wilde, Alexandre Dumas and Mervyn Peake.

She loves using oils but finds them too slow-drying, so almost always works in acrylics. Colour is all-important; she loves the way it can evoke the emotions. She is particularly fascinated by iridescent effects. She uses a lot of sponging, marbling and flogging in her work, and treasures old "abused" brushes: "They can be really handy when it comes to textures like furry moss, tousled hair or crusty bark."

She feels Faery is a kind of utopia. "I think fairies have their priorities right: they live closely with the elements; love and beauty are pre-eminent; they never hold back on their emotions; and they love playing games and tricks on each other as well as on mortals." Visit Maxine's website at www.fataraworld.com.

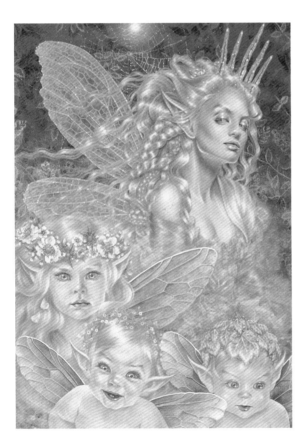

FROST *(LEFT)*
28 x 20 in. Acrylic on canvas. 1992.

This scene depicts a Fairy wedding, with the fairy bride and her flower girls in attendance. The Fairy princess looks rather forlorn because unhappily, this is an "arranged" marriage. I tried to capture all the colours that are reflected in frost and ice crystals in order to impart the coldness of her emotions, hence the title *Frost*.

ELF QUEEN *(FACING PAGE)*
25½ x 18 in. Acrylic on canvas. 2001.

*Elf Queen* was a request from someone who saw my work *Elf King*. I particularly enjoyed doing this painting, because it had been several years since I had painted the king. It was quite a challenge to make them look as if they "belonged" to each other.

**FOREST SPRITE** *(RIGHT)*
16½ x 11½ in. Acrylic on canvas. 2001.

My husband and I went rambling through the breath-taking Karri forests situated in the lower south-west of Australia. The place is amazingly enchanting, and beneath the 300-ft trees lives a world of moss-covered logs and rainbow-coloured fungi. I couldn't think of a better place to discover a sprite venturing into the dark woods.

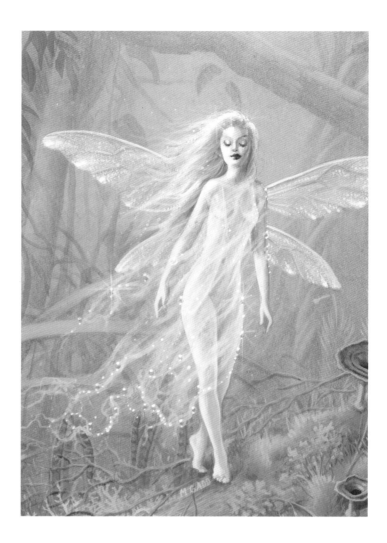

**AMY LEE** *(BELOW)*
25½ x 18 in. Acrylic on canvas. 2000.

I was totally captivated by my beautiful and extremely fairy-like young niece when I painted this. I make no apologies here – she was pure inspiration!

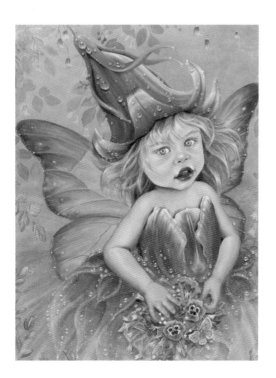

*" I'm not really sure why I wake up in the morning and want to paint. It's all I've ever known. I might as well be asked why I eat or breathe or sleep. "*

**CHRYSELLA** *(FACING PAGE)*
28 x 20 in. Acrylic on art card. 1994.

Chrysella is a beautiful young woman who possesses a great deal of attitude and inner strength, just as her expression reveals. She will need it in the fairy realm, and this painting is deliberately intense and confronting, which many people seem to appreciate!

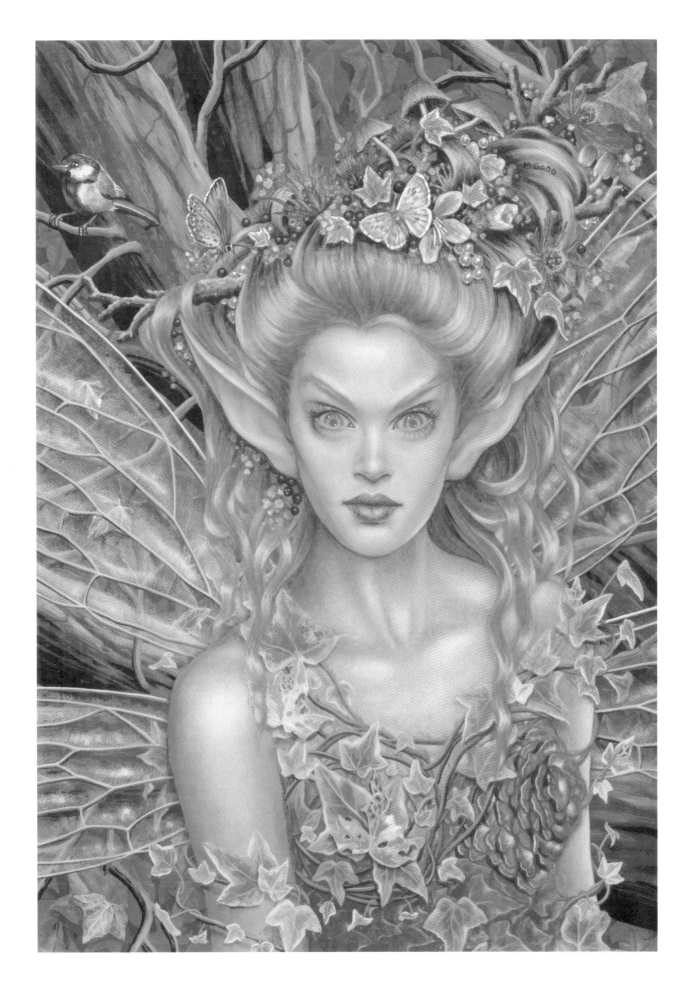

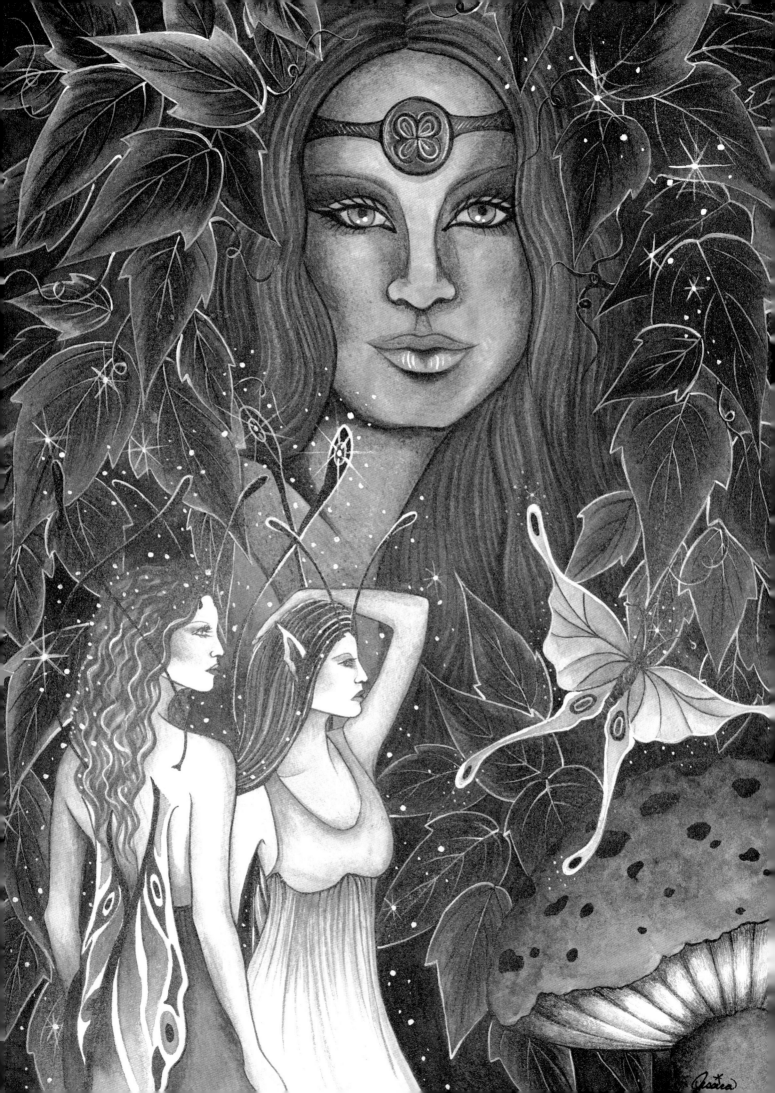

# JESSICA GALBRETH

*" A very interesting gentleman I once met who has an affinity with fairies claims I was kissed by a fairy as a young child and then was enchanted to paint them for the rest of my life. "*

Jessica Galbreth was born in 1974 in Toledo, Ohio, and fell in love with fantasy art at a very early age. In high school she showed a great talent for painting and drawing, and she went on to major in Fine Arts at the University of Toledo, with a focus on painting the human figure. As a newly graduated artist, it seemed only natural to her that she should direct her professional career towards the fantasy and mythological art that had for so long been her great love.

After putting together a small collection of fantasy paintings, she was persuaded by friends to post her work on a website, and since then she has never looked back. There's now a tremendous selection of images on offer at her website, www.enchanted-art.com, in the form of prints and cards. She occasionally takes on a commission as long as she feels the designated subject matter will not restrict her own ambitious expressions and visions, but most often she

TITANIA *(RIGHT)*
11 x 14 in. Watercolour. 2002.

Standing before the gnarled trees, which surround her enchanted kingdom, Titania beckons us with her gaze. The legend of Titania hails from Shakespeare's *A Midsummer Night's Dream*, which depicts her as a queen of the faeries taking her place alongside her husband, the faery King Oberon.

TUATHA DE DANAAN *(FACING PAGE)*
11 x 14 in. Watercolour. 2002.

This piece shows the more earthy colours to which I am partial. Under her protective watch, the children of the Goddess Danu, the Tuatha De Danann, frolic within the lands of Eire, spreading their magic and enchantment. This ancient race who sprang from mother Danu eventually became the deities of Ireland.

prefers the artistic freedom of painting her own ideas.

She has an immense interest in Celtic – particularly Irish – mythology, and draws much inspiration from it. Celtic-themed music, too, especially that of the Celtic harp, is a good source of creativity.

The fairies she paints tend to be beautiful winged women, their features generally human except for the pointed ears, and, of course, the wings. The wings are always different, contributing to the unique look of each of her fairies. She has always been drawn to painting the denizens of Faery: "I'm not sure why, but I was encouraged by the example of wonderful fairy and fantasy artists like Brian Froud and Alan Lee. Their illustrations inspired me to see the reality of Faery in a whole new light."

After a first drawing done using a fine-point pencil and a kneaded eraser, she works mainly in watercolours, usually Winsor & Newton paints because she reckons they're the smoothest and mix well together. She begins with the skin tones, as she finds these the most difficult to get exactly as she wants them. She adds extra touches in acrylics and inks. Last of all comes the background. She may use airbrushed white to give a particular painting an ethereal look. She favours 300lb Arches cold-press watercolour paper; this paper is very thick – almost like cloth – and she finds it doesn't warp as she works with watered-down paints. Depending on the size, a painting can take anywhere from seven hours to a full day to complete.

Jessica uses a wide variety of colours, and loves manipulating them. Each individual painting will, however, generally have a scheme of just two or three colours in various shades. In her own personal perception, dark blues and greys represent mystery and magic, while the browns and the greens indicate the wonders of nature.

uses a lot of white starbursts to convey a feeling of magic and enchantment.

Jessica lives near a park with giant oaks and old pines. A walk along its paths, among the twining vines and foliage, never fails to renew her energies and fill her with ideas for further fairy paintings. Her work can be viewed at www.enchanted-art.com.

CELESTIAL FAERY (ABOVE)
11 x 14 in. Watercolour. 2002.

With gossamer wings held against a cosmic backdrop, the Celestial Faery appears in all her glory. Wearing her moon crown and celestial adornments, she conjures up a new star in a swirl of sparkling faery dust.

SPRING FAE (*Above*)
11 x 14 in. Watercolour. 2001.

Adorned with fuchsia petals and twining vines, the Spring Fae
beckons with her seductive gaze as she warms the earth and
brings forth the flowers and leaves of the season.

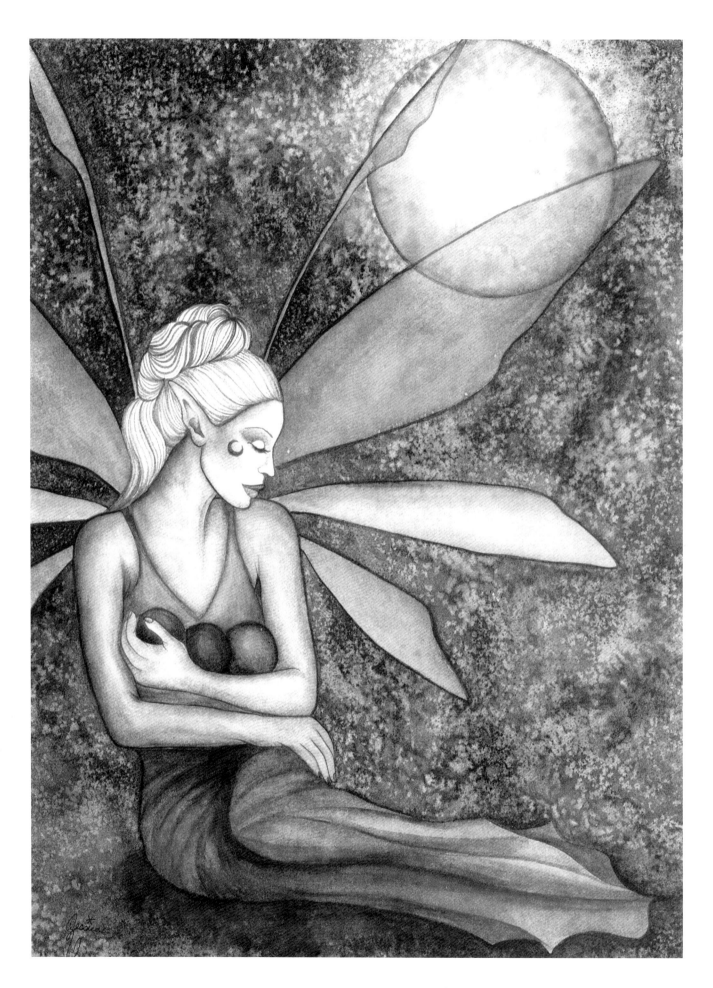

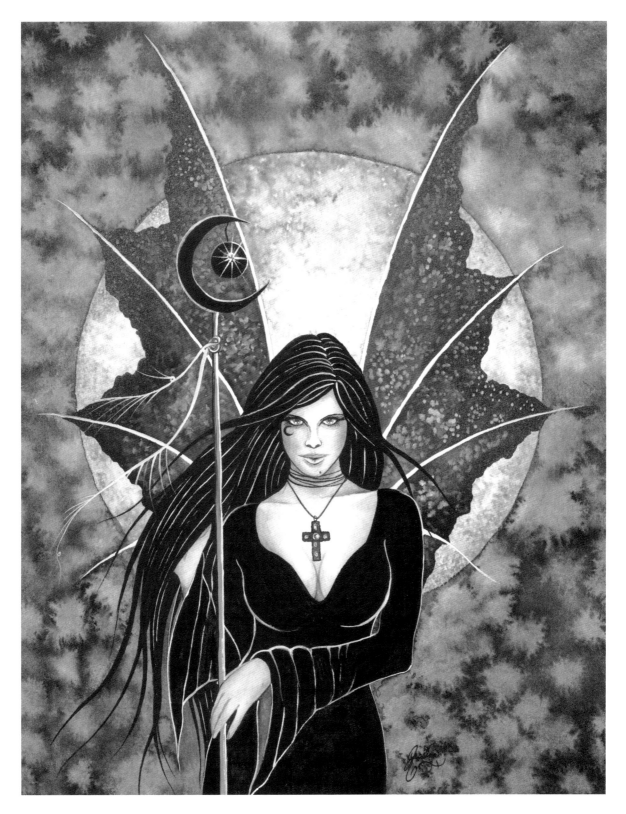

**FAIRY MOON** *(FACING PAGE)*
11 x 16 in. Watercolour. 2002.

Clutching three magical moonstones, a fairy rests beneath
the lunar orb above. Bathed in an opaque glow of moon-
beams, she sits peacefully with gossamer wings out-
stretched.

**GOTHIC FAERY** (*ABOVE*)
11 x 14 in. Watercolour. 2002.

Wielding a moonstaff made from the blackest onyx, the
Gothic Faery flashes a piercing gaze filled with dark
enchantments. With her indigo wings held aloft, she
stands defiantly in front of a full moon as her raven hair
flows behind her in the night winds.

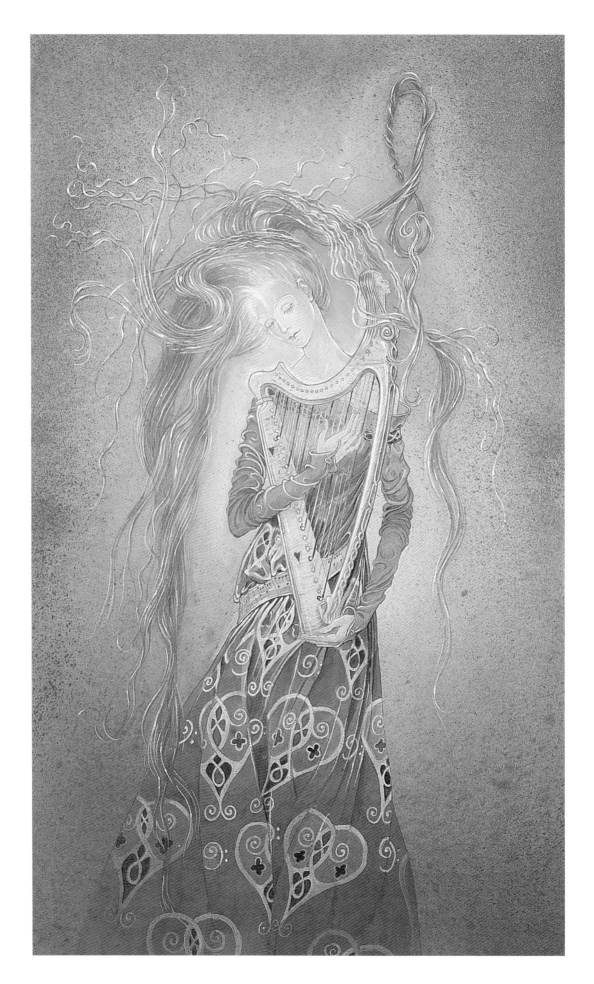

# Marja Lee Kruÿt

*" Spirituality is of great importance to me, and I base my work on it and a mixture of symbolism, mythology, visionary dreams, mysticism, intuition, play and humour. "*

Marja Lee Kruÿt was born in 1943 in Holland's northeastern province of Drenthe. She taught herself to draw until the age of 15, when she went to Amsterdam to spend five years studying fashion illustration and design. In 1964 she moved to London and began creating fashion drawings for major stores in England and elsewhere as well as for newspapers and magazines, including *Vogue* and *Harper's Bazaar*. She was involved in ballet, too, sometimes as a dancer but also as a costumer for various productions. For a time she made clothes for a Pimlico boutique that catered to the likes of Marianne Faithfull, Pete Townshend, Brian Jones and Mick Jagger. She now lives in Devon, in the southwest of England, as do many other fairy and visionary artists including Brian and Wendy Froud, Alan Lee, Marc Potts and Hazel Brown.

As a child, Marja was inspired by the *Prince Valiant* comic strip, featuring a young man in Arthurian times. As she grew up her tastes became more sophisticated: she regards her lifelong influences as being the artists of the Symbolist movement, the visionary artists, the Pre-Raphaelites and the Surrealists. Her brother, Dick Kruÿt, is also a visionary artist, and he taught her much about how to see. She also feels an affinity for artists such as William Blake, Botticelli, Gustav Klimt and Odilon Redon – not to mention her daughter, Virginia Lee, herself a visionary artist.

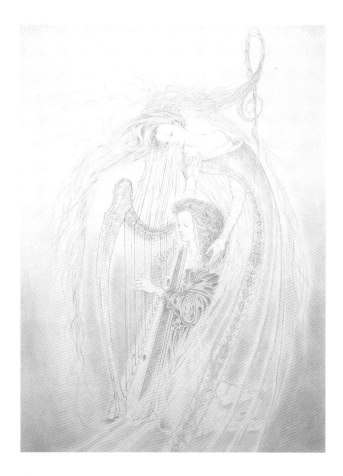

THE MUSE (*Above*)
15¾ x 11½ in. Pencil. 1998.

When playing my harp, I often feel and imagine we have unseen guides, angels and faeries assisting us. Magic followed from this drawing; a harpmaker copied the harp from the picture, which I now own and am delighted with.

DREAMHARP *(Facing page)*
17¾ x 12½ in. Watercolour. 1999.

A variation on *The Muse*, which was to be in colour also, *Dreamharp* was a trial, to see how it would work, and became a picture in its own right.

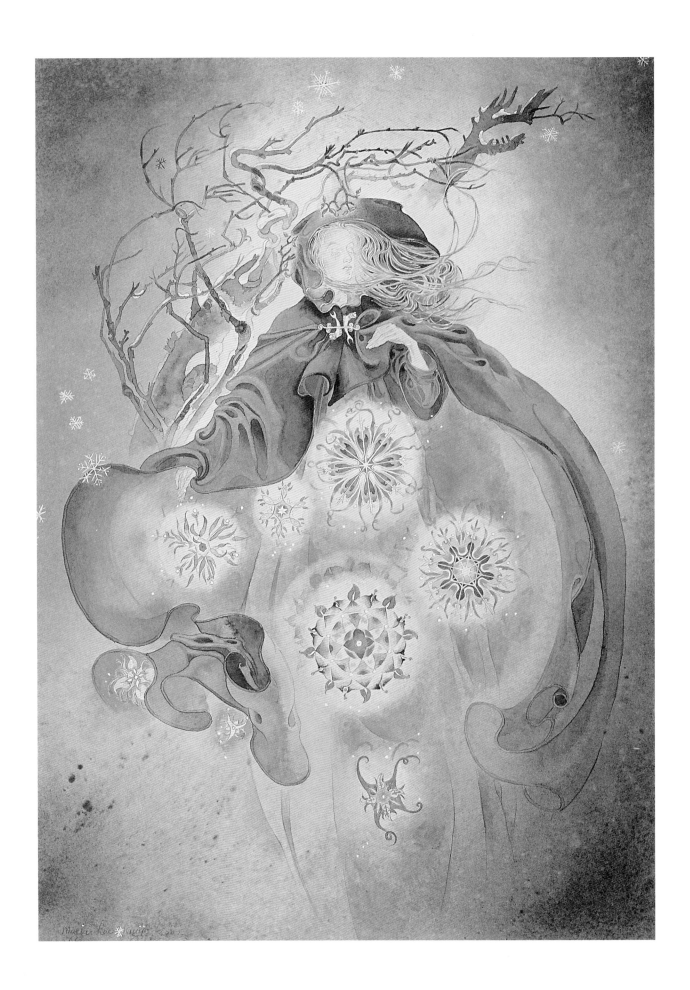

UNITY *(RIGHT)*
21¼ x 13¾ in. Watercolour. 2000.

This was a commission from a lady as a gift to her husband, who had a great interest in the Orient and Dartmoor where he lives. The dragonfly symbolizes summer in China, and in that summer, dragonflies hovered over the couple's garden pond for the first time.

MONTH OF MARCH *(FACING PAGE)*
19 x 13¾ in. Watercolour. 2002.

This depicts a transformation scene from winter into spring and was a commission for my niece, who was born in March. The mandalas of flowers represent their templates in geometric form, before they manifest themselves in nature as flowers, as we get to see them eventually.

> **" *I live surrounded by very old land, and the stones seem to whisper hints of memories to me.* "**

Over the past 20 years she has also been deeply interested in Celtic art and music, and she plays the Celtic harp, or clarsach. Legends and mythology have always been Marja's greatest inspiration.

For drawing she works in graphite pencil, conté pencil or charcoal, sometimes with a colour wash. Her paintings are done mainly in watercolours. She finds the medium "emotionally satisfying to me. It can convey a dreamy, atmospheric mood which I like. Watercolours can create happy accidents; sometimes unexpected images can start to appear as the paint dries. These are particularly important to me as a kind of information that I will certainly use in the finished painting." Usually she starts with just one or two main colours, keeping everything as simple as possible and relying a lot on drawn lines to show the image. Beforehand she will have done many sketches to satisfy herself with the composition.

Fairies are often featured in her paintings, if their presence is appropriate. She regards fairies as being part of the angelic kingdom, designated to the sphere of the Earth and to Mother Nature. She feels that, the more we become in tune with ourselves, the more we can connect and harmonize with the fairies, as with all aspects of nature and the universe. Visit her website: www.visionary-artist.co.uk.

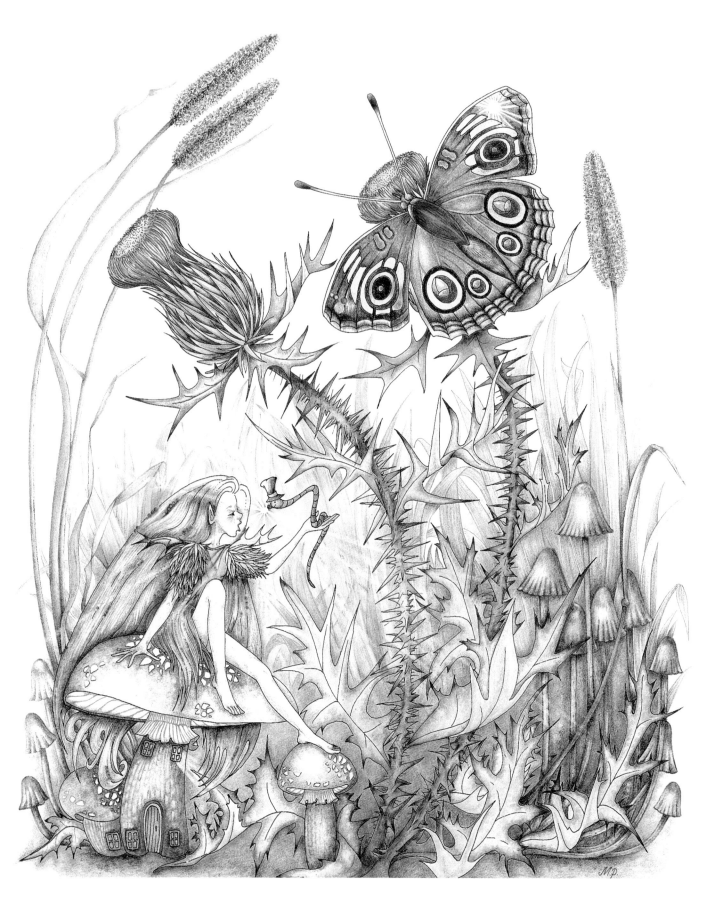

# MYREA PETTIT

One of three children, Myrea Pettit – the name is pronounced "Maria" – was born in 1970 in Northamptonshire, England. Times were not easy for the family, and they couldn't afford to go on many outings, so Myrea, her older brother Mark and her younger sister Michell were encouraged to draw, paint and colour. The three competed to see who could produce the best likenesses, particularly of eyes, mushroom houses and rickety old beamed cottages. In particular, Myrea and her sister were always dressing up as fairies and looking for the real thing in what they believed were fairy hideaways among the thatched cottages of the quaint old village where the family lived. "Was I blessed as the only one who saw the fairies?" she recalls now. "Maybe I was the only one who *believed* in them!"

Aside from art classes at school, she has received no formal training. She regards her tremendous skill at drawing and painting as a gift from God, and a consequence of all those long childhood days practising. Both Mark and Michell in due course became artists as well – Michell focusing on nature and wildlife, and Mark becoming fascinated by pointillism and graphic design. But fairies were always Myrea's favourites, even though dinosaurs and Roger Hargreaves's *Mr Men* characters were popular among the three children as well.

Among the books they read were those by illustrators whom Myrea lists among her abiding

THE GLOW-WORM FAIRY *(LEFT)*
16 x 11 in. Colour pencils. 2001.

I had to leave my guests in my garden when this glow-worm came to me. I had never felt so much pain as that caused by her energy. I had to completely break away. It was she who made me use my gift, to show her flowing through my hand onto the paper.

AURELIA (THE TOOTH FAIRY) *(RIGHT)*
16 x 11 in. Colour pencils. 2002.

She is a beautiful fairy, with so much love and passion in her heart and an aura of protection around her as she looks over children as they sleep, until the dawn fairy takes over.

TULIP PETAL FAIRY *(RIGHT)*
16 x 11 in. Colour pencils. 2001.

influences: Kate Greenaway, Holly Hobbie, Cicely Mary Barker, Michael Hague and Janet and Anne Grahame-Johnstone. She especially recalls a book that belonged to her mother: *A Day in Fairy Land* (1948) by Ann Mari Sjögren. It was in this that she met some of her first fairies.

> " *Though they can be quite mischievous, I draw for the fairies. They have a message to convey of inner peace, beauty and kindness.* "

She finds that music influences her artistic moods and spiritually lifts her: classical works by composers such as Tchaikovsky, Beethoven and Vivaldi as well as more recent music by "intelligent

musicians like George Gershwin and George Harrison". Among her favourite reading matter are the works of Shakespeare, the poems of Wordsworth and "the genius of Spike Milligan".

She starts each new picture with a pencil sketch, first having decided on the picture's focal point. She first sketches the head and body proportions, then follows with the face and hands and feet. Once happy with the sketch, she inks the image using very fine Rotring technical pens; the resulting line drawing may also be used for one of the children's colouring books she creates. Next comes the colour. She favours Berol's Karismacolor range of pencils, with over 120 colours, finding they blend well as she builds up the marks to make new colours. When colouring she gets the best effects by working in circular motions rather than straight lines.

Myrea uses a variety of bleedproof papers and Daler–Rowney's acid-free cartridge paper. She finds these accept her pen-and-ink-and-colour-pencil technique well.

Looking at the maturity of her work today, it's hard to believe that she feels it wasn't until she was 28 that she began really to be able to express her love of Faery art. Thanks to a chance meeting, she was given the opportunity to start her website, Fairies' World (www.fairiesworld.com), as a showcase for her work. Not surprisingly, it soon began to attract a lot of international attention. "The interest gives me so much inspiration in my work. Even more meaningful, the site has generated a bringing-together of some wonderfully talented artists of like mind whom I admire greatly, not just for their skills but for their advice, kindness, friendship and kindred spirit. Many of them, in fact, are featured in this book."

THE OLDEST LIBRARIAN *(RIGHT)*
16 x 11 in. Colour pencils. 2003.

*The Oldest Librarian* is my favourite piece to date. Not only has this image stretched my creative ability, but it has given me my greatest challenge with light and shadow. It was painted for my friend in Colombia, the author Vicente Duque, as an illustration for his book *The Fairy Girls*.

 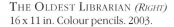

*" My fairy world is very real to me. Images of charm and magical beauty and innocence are waiting to appear from the little people who trust me so much – to bring a glimmer of hope, an innocent smile from a child, or a memory of a parent in a happy childhood past, telling bedtime stories. "*

CHIRON *(ABOVE)*
16 x 11 in. Colour pencils. 2002.

This fairy was inspired by Chiron, the inventor of the constellations. His wings are from one of my favourite butterflies, the Marbled White.

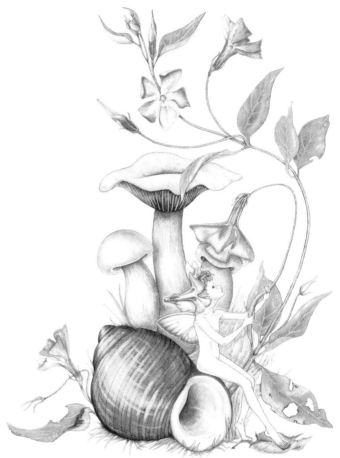

THE MUSHROOM AND WINKLE FAIRY *(ABOVE)*
16 x 11 in. Colour pencils. 2001.

My love for my children and capturing those moments of their early childhood are a source of constant pleasure. Here my eldest daughter Charlotte inspired me as she played with a little shell she had found at the end of the garden among the periwinkles.

BUTTERCUP FAIRY AND ACORN PIXIE *(LEFT)*
16 x 11 in. Colour pencils. 2002.

This fairy was among a group of buttercups in my garden and was filled with the wonderful energies of nature. She felt beautiful at the time, and daring as she teased her pixie playmate, who blushed at the flirtation but glowed yellow.

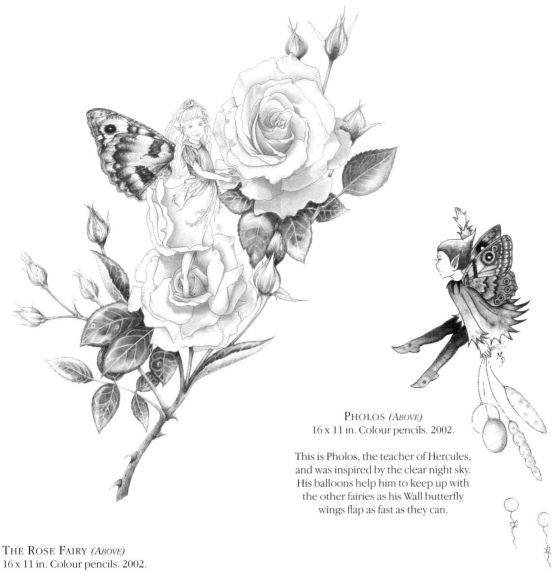

PHOLOS *(ABOVE)*
16 x 11 in. Colour pencils. 2002.

This is Pholos, the teacher of Hercules,
and was inspired by the clear night sky.
His balloons help him to keep up with
the other fairies as his Wall butterfly
wings flap as fast as they can.

THE ROSE FAIRY *(ABOVE)*
16 x 11 in. Colour pencils. 2002.

I was inspired to capture my little daughter Eleanor Rose in
this drawing after a trip to Spain. We had spent one day
nosing around the rocks looking for shells and hermit
crabs. When I came home it all came flooding back, and the
result is Eleanor Rose, my very own fairy, with the wings of
the Hermit butterfly.

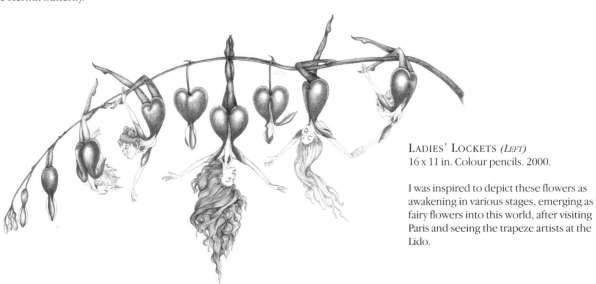

LADIES' LOCKETS *(LEFT)*
16 x 11 in. Colour pencils. 2000.

I was inspired to depict these flowers as
awakening in various stages, emerging as
fairy flowers into this world, after visiting
Paris and seeing the trapeze artists at the
Lido.

# NATALIA PIERANDREI

This remarkable self-taught fantasy artist was born in the late 1970s in Jesi, in the central part of Italy, and grew up in Fabriano. One of her earliest memories is of her mother teaching her to draw daisies; throughout childhood she seemed to be drawing constantly on whatever scraps of paper she could find. She also pored through her parents' art books, falling in love with the works of Hieronymus Bosch and Leonardo da Vinci. She inherited from her father an interest in comics and science-fiction movies, and from both parents a love of literature and art. During high school she drew cartoon parodies to amuse her classmates and became seriously interested in fairies and mythology. She studied Latin, Ancient Greek, philosophy, history and literature – but not art. At university in Venice she took her Bachelor of Arts in East Asian Languages and Cultures; during these years she also travelled around Europe and the East. Afterwards she taught Italian for a while in Tokyo.

The Oriental influence is clear in her work, much of which has strong overtones of anime: "My type of drawing is characterized by a mixture of the conciseness of Japanese art with the pleasure in the ornamentation of Art Nouveau and 16th-century Italian painting, comic style." In addition, she has a penchant for Gothic imagery.

While at university she discovered a small shop near her flat that sold fairy-related merchandise, including illustrated books. Among her friends were some architecture students who taught her "just about everything I know about traditional artistic media and the wonderful markers I love to use. As soon as I discovered these I knew they were to be the tools for my art." Today she uses Pantone Trya markers by Letraset, Comic Twins markers by Maxon, Caran D'Ache

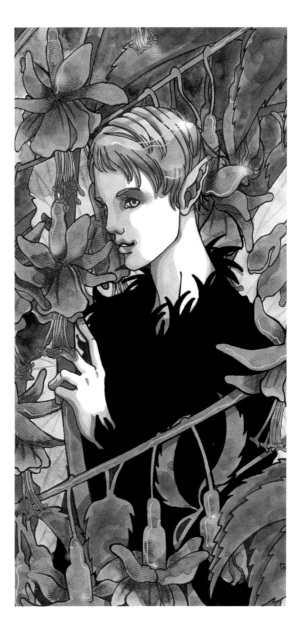

THE FUCHSIA FAIRY BOY *(RIGHT)*
7½ x 13 in. Markers, watercolours and coloured pencils. 2002.

Here is a little fairy friend of mine who loves chocolate cookies!

GARLANDS OF ROSES *(FACING PAGE)*
8¼ x 11½ in. Markers, watercolours and coloured pencils. 2002.

My style is often characterized by an obsession for Art Nouveau: I adore the sophisticated arabesques and stylized, elaborately decorated figures of this artistic movement. I think that *Garlands of Roses* reflects very well this passion of mine.

water-soluble pencils, Stabilo soft pastels and Faber Castell coloured pencils, her preferred paper being Fabriano Tecnico #6. Sometimes she uses watercolours to accentuate certain aspects.

She started her website, www.nati-art.com, after completing her degree, and "in some ways it has changed my life". Through it she has been able to exchange ideas and skills with artists all around the world, and to meet others who share her love for Faery.

Although she describes art as her "great passion", and although she is prolific, art is necessarily still a spare-time occupation for her, done alongside her career in banking; she is regularly approached about commissions, but not at a level sufficient for her to make a living from her art. Perhaps this, the first book publication of her work, will change that.

FORGET-ME-NOT FAIRY *(BELOW LEFT)*
9½ x 13 in. Markers, watercolours and coloured pencils, Adobe Photoshop 6.0. 2002.

My own version of the small, pretty flower fairy's lushly delicate beauty. The shaded black background was made by using Adobe Photoshop 6.0.

WINTER ORCHID *(BELOW RIGHT)*
8¼ x 11½ in. Markers, watercolours, coloured pencils and soft pastels. 2002.

This fairy sings her song sitting on a pink orchid, wondering what mischief she might create upon a group of passing travellers.

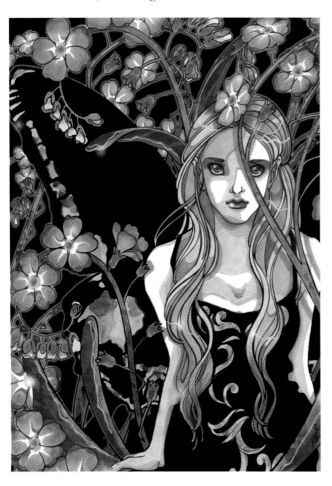

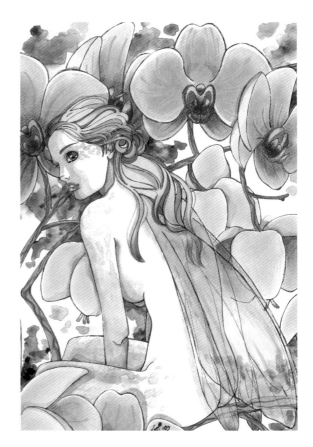

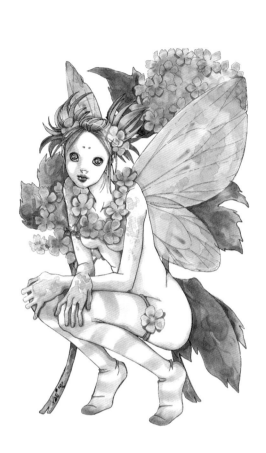

**GUELDER-ROSE FAIRY** *(ABOVE)*
8¼ x 11½ in. Markers, watercolours and coloured pencils.
2002.

I usually like to draw richly decorated backgrounds, so this
is not a typical piece of mine. But, like *Mushrooms and
Violets* it had been done as a possible website layout image.
I especially like the fairy expression … she is probably an
incurable daydreamer!

**NIGHT SKY** *(ABOVE RIGHT)*
9½ x 13 in. Markers, watercolours and coloured pencils.
2002.

I used a mix of markers, pastels and watercolours to
accentuate the cloudy, atmospheric sky. I have never been
concerned with conventional colour theory. And, in my
opinion, this illustration is a proof of that.

**MUSHROOMS AND VIOLETS** *(RIGHT)*
8¼ x 11½ in. Markers and coloured pencils. 2002.

Most of my illustrations are usually sepia-toned with just a
few coloured accents. The colours emphasize the main
elements of the piece, violets and leaves in this case. This
illustration was done as a website layout decoration.

# STEPHANIE PUI-MUN LAW

" *When I walk through my day, if something catches my eye – a lantern at night, a carving on a wall, a leaf on the sidewalk – my mind just starts to imagine it in an image.* "

Born in New York in 1976, Stephanie Pui-Mun Law has lived in California since she was seven. She has been drawing as long as she can remember; one of her earliest memories is, aged about three, being taught by a worldly-wise five-year-old the *proper* way to draw a sunny day – "A quarter-circle yellow sun in the corner, and a strip of cerulean blue about a quarter-inch thick going across the top of the page"! In later childhood she was encouraged by the example of an artist uncle, and through her schooldays took occasional extramural classes in art, including oil painting. For a while she studied with a Chinese woman who taught her about Chinese painting: "It's a deceptively simple style that is actually incredibly complex to master." Since majoring in Fine Arts at

Berkeley she has produced work for role-playing games, card games, magazines and book covers; but always at least half of her work is for herself.

Her influences include the Surrealists, the Pre-Raphaelites, Alphonse Mucha, Michael Parkes, Daniel Merriam, Alan Lee and Brian Froud. However, she adds, "I'm very much influenced visually by aspects of nature. The random formations of clouds, the way a tree branch twists and curves, the streaming of sunlight through windows or foliage." She also draws inspiration from many cultures: Chinese (she is of Chinese extraction), Celtic, Greek, Roman, Roma [sic] and Indian, among others.

For each new painting she first does a rough sketch, then scans it so she can play with it in

FEY DREAMS *(RIGHT)*
9 x 12 in. Pencil. 2002.

The twisted branches seem to contort to cradle this sleeping figure. So quickly has his vision glazed with sleep that he never notices the shimmering figures that separated themselves from the bark of the tree; the spindly twigs break off into spritely phantasms; the twirling leaves dance away with mischievous pirouettes.

DUIRWAIGH *(FACING PAGE)*
20 x 28 in. Watercolour. 2002.

This was done on commission for Duirwaigh Gallery, Kennesaw, Georgia, USA, for a Tribute to Arthur Rackham exhibit, held in October 2002. Fey spirits twist their forms throughout the tree of this doorway into a magical realm.

Adobe Photoshop. Once she gets the composition she wants, she flips the image, blows it up to final size and prints it out. She traces over the lines on the printout in graphite pencil, puts the printout face-down on illustration board, and using the pressure of her thumbnail transfers the graphite marks to the board. She doesn't sketch all the details onto the board: "I like to let those pop up as I go, and surprise myself."

Her preferred medium is watercolours – Winsor & Newton cake paints as opposed to tubes, mainly because she can easily take them with her should she travel from home. She likes Strathmore lightweight illustration board. She uses thin washes with watercolour to build up the intensity of the colour values slowly. On occasion Stephanie works digitally, using Adobe Photoshop or Painter and a pressure-sensitive Wacom tablet.

She has no particular colour preferences: "I use whatever suits the painting. Sometimes I choose colours for no other reason than having used too much of one colour in the last few paintings, and wanting to do something different." She does, however, like to use complementary colours in the main scheme of a painting: blue with orange, red with green, yellow with purple, and variations thereon. It may take her anywhere from a couple of hours to a week to complete a painting.

Although she has painted fantasy, mythology and legend for a long time, it is only in recent years that fairies "have been wiggling their way into my work. It wasn't a conscious decision." They need not be just the main focus; she also likes to incorporate them into the objects and elements of the background – "along the grain of wood, into the pattern of a wall, wispy and fading into shadows in the sky."

A further aspect of her art is the concept of sacredness. As she puts it: "It is that sense which I try the most to convey with my work, a sense of wonder for things within the human experience that somehow sit upon the edges of our consciousness."

A selection of her works in various styles is on display at www.shadowscapes.com.

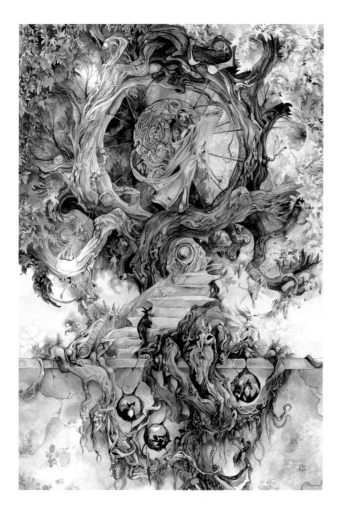

Entwined (*Left*)
20 x 28 in. Watercolour. 2002.

Like lovers locked in a long embrace, twisting, twined, and tangled, tumbling towards the sky, these leaves draw rustling sighs. A hundred thousand years have marked their journey on the rings of the bark.

Singer of the Woods (*Facing page*)
15 x 20 in. Watercolour. 2001.

A beautiful and mysterious woman enchants a soldier as he spies her among the forest leaves. This was an illustration for fey creatures in a role-playing game "Children of the Sun".

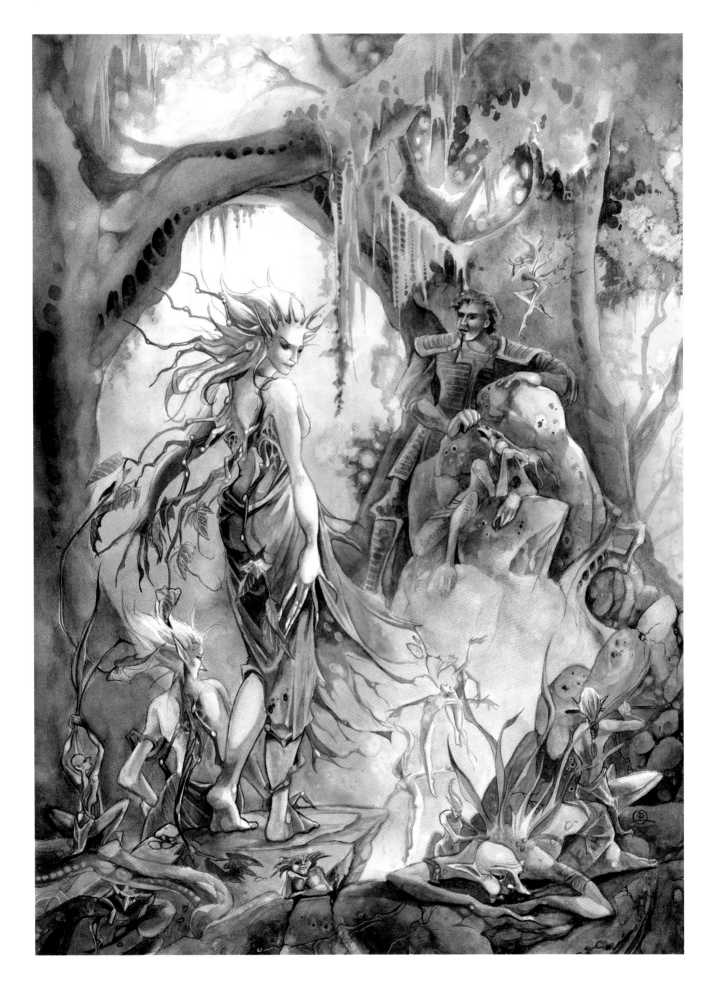

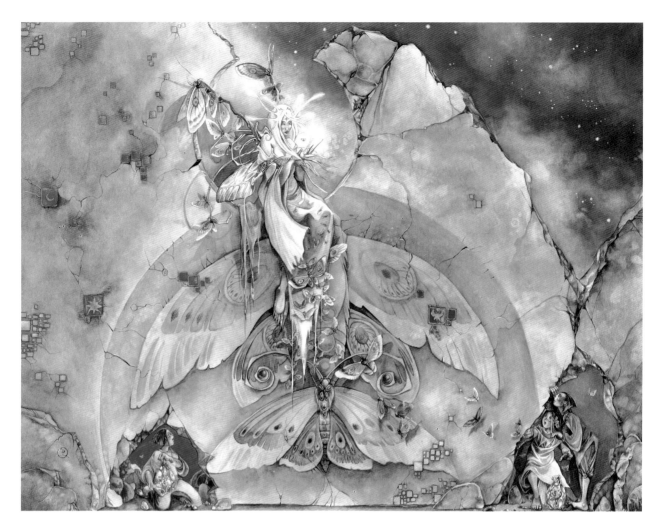

SEEKING THE MOTHQUEEN (*ABOVE*)
21 x 28 in. Watercolour. 2002.

I first sketched this character, The Mothqueen, a year ago.
Since then, she has reappeared in my sketchbooks and
paintings numerous times.

" *Tales in mythology and folklore stem from emotions, needs,*
*desires, hopes and beliefs that have survived for thousands of years*
*across hundreds of cultures. These things are part of the essence of*
*being alive, and of being human.* "

SWEET TO TONGUE AND SOUND TO EYE (*RIGHT*)
21 x 15 in. Watercolour. 2001.

This image depicts an interpretation of the poem *Goblin
Market* by Christina Rossetti; the goblins carrying out their
trays laden with beautiful forbidden fruits.

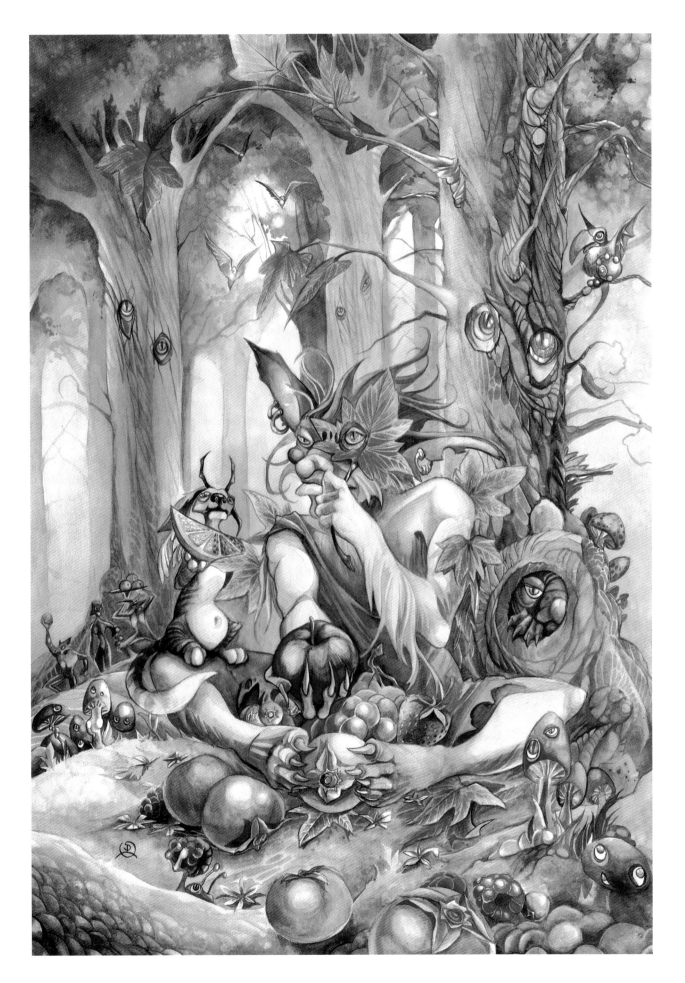

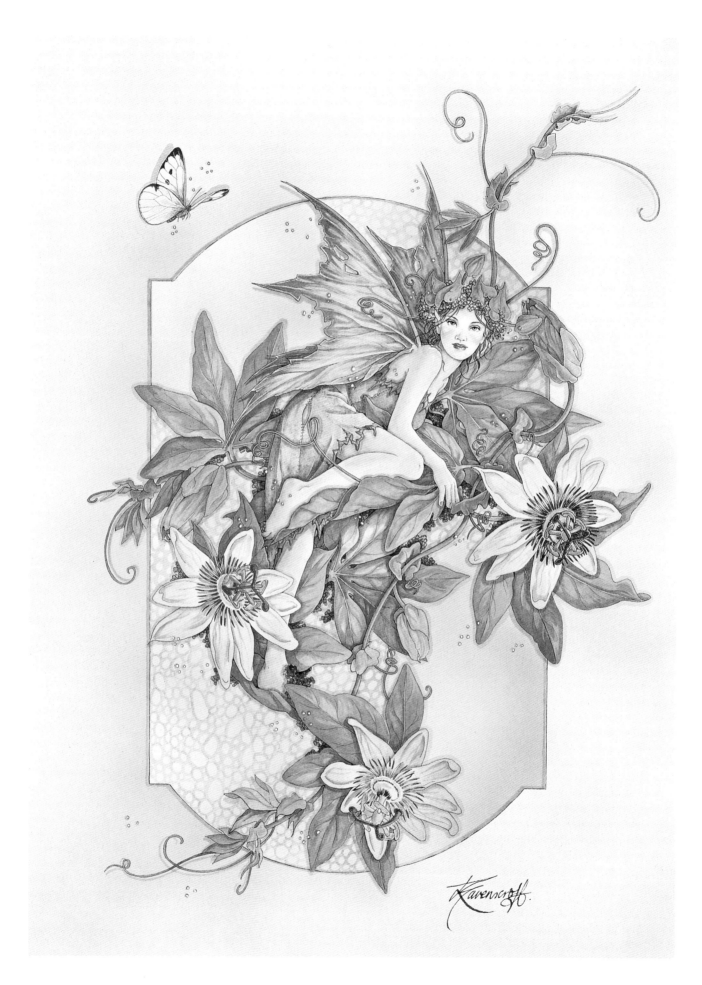

# LINDA RAVENSCROFT

*"All my paintings contain messages within them. These messages are very personal and sometimes quite deep and difficult to explain in words, so I express them the only way I can."*

Born in 1963 in Cheshire, England, Linda Ravenscroft was brought up amid the beautiful countryside there. Her parents taught her about wildlife and nature, and spent many hours telling her stories or helping her search in the woods for fairies and Red Indians. Like so many other successful artists, she cannot remember a time when she was not drawing or painting. Bullied at school, she found painting was a perfect way of escaping: "I could use my imagination to be anyone or anything I wanted to be in my fantasy world. There was no one who could harm me. I guess I still live in this world, but now I am an adult it has a more serious side to it."

At the age of 16 she went to the London Road School of Art. However, owing to lack of finances, she was able to stay there for only a year or so after obtaining her "A"-level in Fine Art. Aside from that she has had no formal training.

Thereafter she worked for over a decade as a receptionist, although – encouraged by husband John – she continued to paint for herself in her spare time, selling the occasional picture to a local gallery or to friends. She had to stop working full-time when she and John had a daughter; the baby was born with a serious hip defect that required many months of hospital treatment. Linda cast around for some way she could continue to make an income that would let her be with her daughter; the solution was her art. She began painting in earnest, selling her work through local crafts fairs and galleries and taking whatever commissions came her way: portraits of people and pets, pictures of houses – anything. "But deep in my heart I knew I just had to let people see the real me." At last she was able to turn to her fantasy realms once more – and to Faery.

Linda says her inspirations come from many sources. "I still rely mostly on my dreams and inner feelings, but now influences from artists of the past and present – such as the intricate

HAS THE RAIN STOPPED YET?
4 x 4 in. Pen, ink and watercolour. 1999.

None of us like rainy days, and Faerie Folk are no exception. I painted this little chap sheltering under a toadstool during a very wet week in autumn. He reminded me of my young nephew, and his mother telling him that he can't go out to play, "not until the rain has stopped".

PASSIFLORA (*FACING PAGE*)
15 x 20 in. Pen, ink and watercolour. 1999.

This little faerie can't resist the perfume from the passionflower, so she takes a chance, hoping she won't be seen hiding amongst the leaves … but I spotted her.

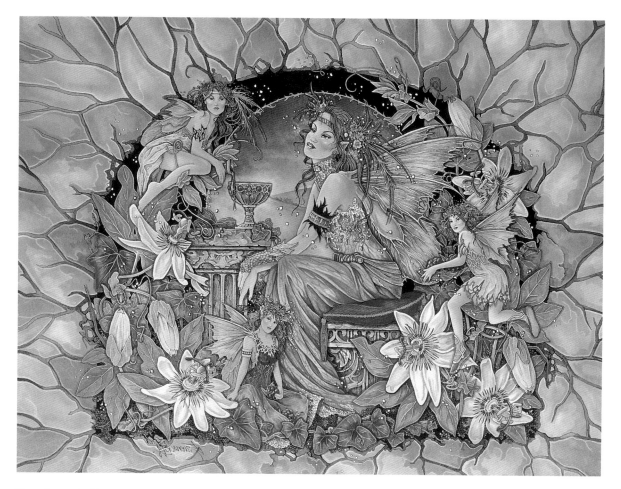

THE QUEEN'S CUP *(ABOVE)*
18 x 20 in. Pen, ink and watercolour. 1998.

Every little girl wishes she was a faerie queen thinking of
a handsome prince. In this picture the Queen is
daydreaming about a true love and her faerie handmaids
are preparing a love potion so that she can capture his
heart. The problem is that the potion won't work without
the Queen's Cup.

designs of William Morris and others of his time
and the beautiful work of Brian Froud, a modern
master of the realm of Faery – and the love of
nature my parents instilled in me, together with
tales of myths, legends and the mysteries of the
supernatural and unexplained . . . All of these
influence me and my work."

When she settles on an idea for a new
painting – the decision "usually depends upon my
mood" – she starts off with sketches. Linda enjoys
the composition stage. Her choice of colours, she
says, comes to her automatically, without much
need for conscious thought. Her favourite media
are pen-and-ink, watercolours and acrylics,
sometimes used individually but most often in

different combinations. Depending upon the
complexity of the subject, it can take her from as
little as a couple of days to complete a painting to
as long as several months. Her glowing Faery and
other fantasy images are now widely featured on
cards and calendars, and a good selection is on
display at her website which can be found at
http://mysite.freeserve.com/ravenart.

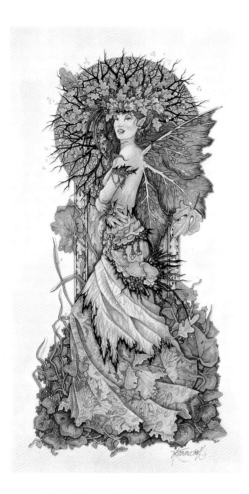

TREE SPIRIT II *(ABOVE)*
8 x 20 in. Pen, ink and watercolour. 1998.

*Tree Spirit I & II* came about when I was talking to my young daughter about the plight of the rainforest and how the trees were being destroyed. I began to wonder what it would take to stop this from happening. Perhaps if a tree was to resemble a beautiful magical woman ...

MYSTIC MOMENTS (A FAERIE PRAYER) *(RIGHT)*
10 x 22 in. Pen, ink and watercolour. 1999.

A mystic moment, a silent prayer, the thread of life breaks free. Faeries pause and contemplate things that are yet to be. Their prayers are said for humankind, a hope that we might see the path of truth on which to tread, to open our hearts and fly free.

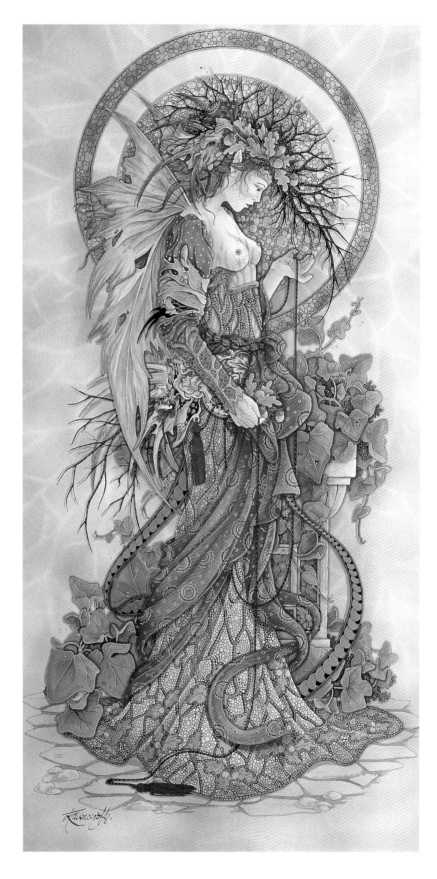

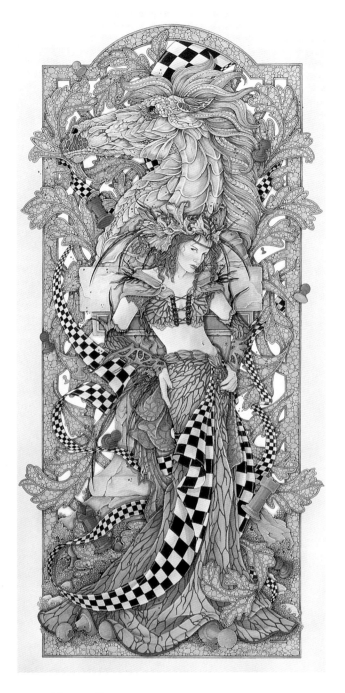

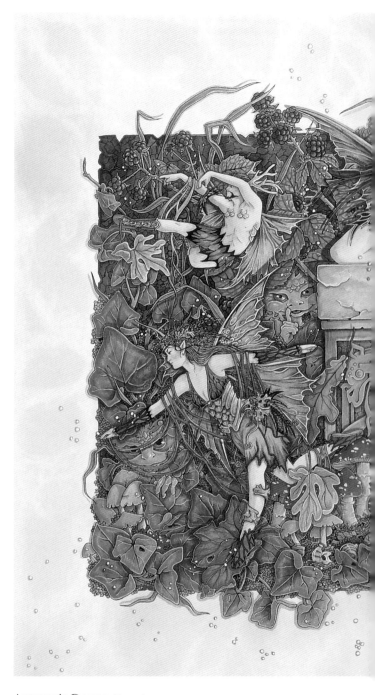

MASTER PLAN (ABOVE)
18 x 30 in. Pen, ink and watercolour. 1999.

I painted *Master Plan* in 1999, when we were
all wondering what the future in 2000 would be
like. The idea of a strategic game of chess came
to mind and the skill a player needs to stay alive
and in the game. I often feel that humankind
needs to play the game of life with a lot more
wisdom and skill.

AUTUMN'S DANCE (ABOVE)
15 x 20 in. Pen, ink and watercolour. 1999.

Autumn is the end of the waking year, a time
when nature prepares to sleep and winter
looms. Faeries enjoy the last fruits of the
season and pay thanks for a good harvest.
The wise Queen can see the future, but her
expression tells no secrets of what her eyes
can see.

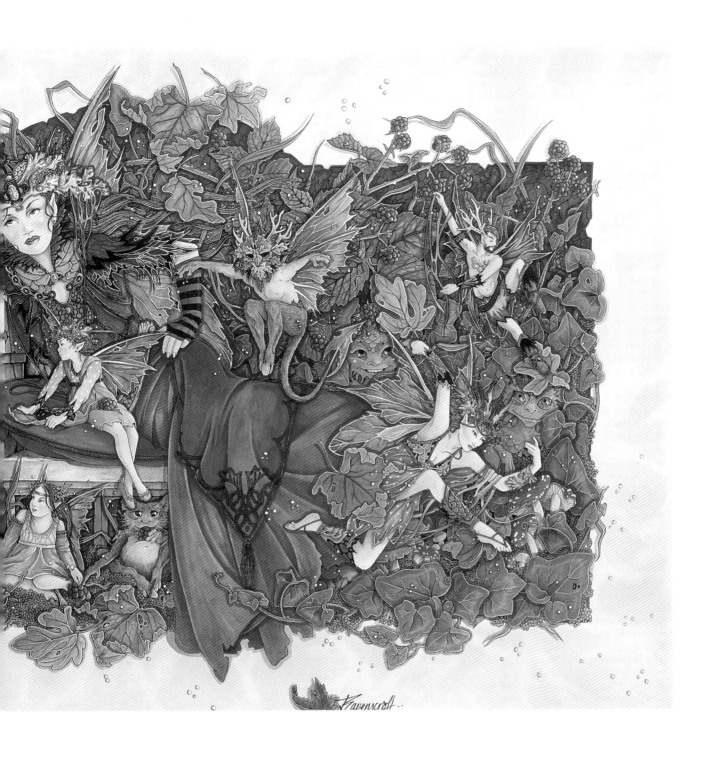

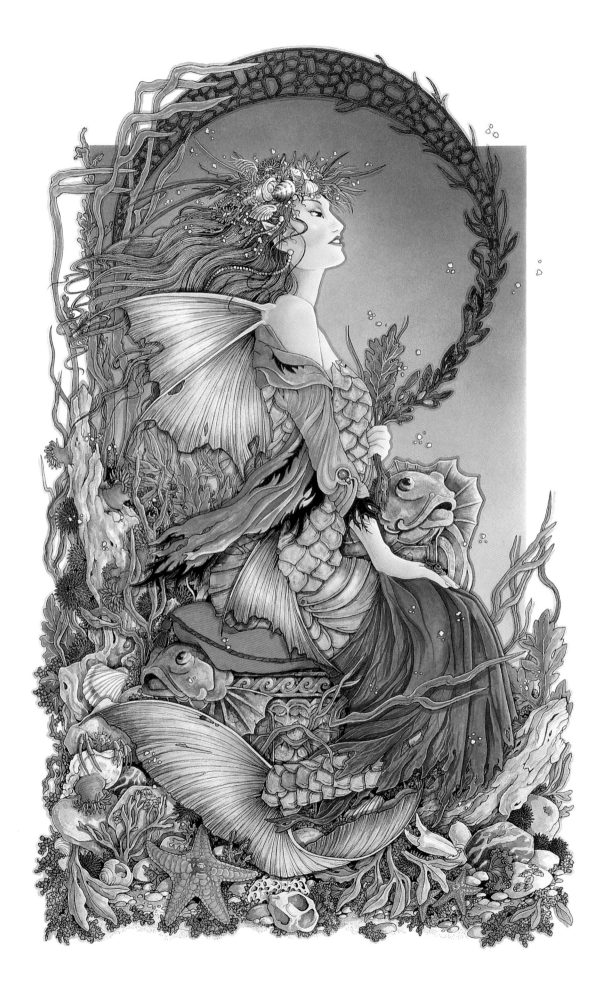

THE THOUGHTFUL FAERIE *(RIGHT)*
18 x 22 in. Mixed media. 2001.

You can't always tell what title a painting
should have nor a reason for creating it in
the first place. That's what has happened
with this piece. When I had finished the
painting I decided that the faerie looked as
though she was deep in thought.

OCEAN'S BOUNTY (*FACING PAGE*)
12 x 18 in. Pen, ink and watercolour. 1998.

This is one of a pair of images representing
Mother Earth and all of her wonderful
creations. I have tried to give the mermaid
a feeling of exuberance and celebration as
befits one of the most beautiful places on
our planet.

# ANN MARI SJÖGREN

" *I am happy as long as I can do the things I love to do. That is what makes the day worth living, and that is what enriches my life.* "

Ann Mari Sjögren was born in 1918 in the small Swedish fishing community Nyhamnsläge, about 20 miles (30km) north of Helsingborg. Her father was an upholsterer and a saddler, and the owner of the village's only taxi. She started drawing in infancy, and drew on whatever she could find, filling the margins of her mother's cookbooks with fancy ladies in elegant hats – Greta Garbo was a favourite.

Encouraged to study by her parents, she went to secondary school in Höganäs and then on to take her higher certificate at the girls' gymnasium in Helsingborg, one of the first institutions in Sweden to offer higher education to girls. In 1938 she went to the Reklamkonstskolan (Commercial Art School) in Stockholm, and in 1940 she was taken on as a trainee by an advertising agency in Malmö. Her first professional job was as a

commercial artist for a Helsingborg department store. During WWII she drove her father's taxi, and in 1943 she married. The young couple bought a summer cottage in the forest by Lake Västersjön, about an hour's drive from Helsingborg. "This was the environment where the fairies were born – and still exist!"

At the end of the war she took a job briefly at the Helsingborg Lithographic Office. Ever since then she has been a freelance book illustrator and commercial artist.

Ann Mari's involvement in the art of Faery came about when she was commissioned to draw the pictures for a children's colouring book. She felt that all colouring books were the same: "A boy and a girl visit a farm in the countryside and meet prosperous pigs. I decided to do something different – hence the fairies!" After the colouring

COVER OF *EN DAG I ÅLVRIKET* (*A DAY IN FAIRY LAND*). TRANSLATED INTO ENGLISH IN 1949 (*RIGHT*)
Ink and watercolour. 1945.

I painted the originals for this book in the spring and summer of 1945. The environment is directly taken from the forest around the cottage we bought in that year. I was born and raised in the flat country near the sea, so I was very inspired by the totally unspoiled nature I found in this forest.

TAKEN FROM *AMONG FAIRIES AND ELVES* BY LENA LINDH WITH DRAWINGS BY ANN MARI SJÖGREN. 2000. (*FACING PAGE*)
Ink and water colour. 1992.

These are really the grandchildren of the fairies of 1945! I had stopped painting for about 20 years, but in the early 1990's I thought I would resume it and depict how the modern fairies were living. In this picture they are dancing on a stump in a blackberry bush.

*" I rarely see the final picture in my head before I start. I have to find my way to it. I always begin by sketching the large shapes. It's very important to get balance and harmony. As a rule, I have to make and remake these sketches several times. I practically never make a picture at once, without sketches and a lot of preparations. "*

FROM *EN DAG I ÅLVRIKET* (*A DAY IN FAIRY LAND*).
TRANSLATED INTO ENGLISH IN 1949. *(FACING PAGE)*
Ink and watercolour. 1945.

The story in this book describes the preparations for the fairy queen's birthday party. In this picture – the first one in the book – we see the Queen busy with her morning toilet, assisted by two elves.

FROM *EN DAG I ÅLVRIKET* (*A DAY IN FAIRY LAND*).
TRANSLATED INTO ENGLISH IN 1949. *(ABOVE)*
Ink and watercolour. 1945.

Here, on a beautiful summer's day, we see two fairy friends sitting on the balcony drinking tea, laughing and talking. Below, three friends study and discuss the cloth that one of them has bought to make herself a dress.

FROM *EN DAG I ÅLVRIKET* (*A DAY IN FAIRY LAND*).
TRANSLATED INTO ENGLISH IN 1949. *(RIGHT)*
Ink and watercolour. 1945.

Wild strawberries are very much a part of summer. They grow more or less all over Sweden. When the children find some, they like to thread them upon a straw, and sometimes give it as a present to someone dear. Here you can judge the size of my fairies: about 3–4 inches.

book had been published, Ann Mari developed it into the book *A Day in Fairy Land* (1948). That was the first of many books devoted to Faery, among them the elegant *Wedding Bells in Fairy Land*. And of course there were countless cards, calendars, advertisements and other illustrations.

At the beginning of the 1960s, photographs superseded illustrations in advertising, and she worked occasionally as a teacher. In 1969 she started holding batik classes in her home; these were enormously successful, and continued for 20 years – during which time she painted little. On moving in 1989 to Helsingborg she found that one of her neighbours was the author Lena Lindh; in due course they produced two books together, Lena writing the texts and Ann Mari painting the illustrations.

Ann Mari works almost exclusively in watercolours (she favours Winsor & Newton), painting with sable brushes of various shapes and sizes. She also does a little work in pencil and a little in oils. She has a web page at www.fairypaintings.com.

# PAULINA STUCKEY

" *When a wave of inspiration hits, I'm surprised to find dancing*
*forms of shadow and light moving in the corner of my eye,*
*only to lose those forms when I turn and try to catch them.* "

Paulina Stuckey was born in 1970 in Ontario, Canada. She started drawing aged about three, and her parents still have many of the pictures she did in childhood. She was inspired by animated creations like Bugs Bunny and the Disney characters, and this still showed in her work when at age 14 she began doing the editorial cartoons for a local newspaper. After high school, she spent three years at Sheridan College in Oakville, Ontario, majoring in Book Illustration.

She hugely admires the work of the great fairy painters like Richard Doyle, Arthur Rackham, Richard Dadd, Charles Folkard and J. Anster Fitzgerald. Also inspiring are the writings of Lewis Carroll, A.A. Milne and J.R.R. Tolkien and the music of artists like Loreena McKennitt, Kate Bush, David Bowie, The Cure and Radiohead.

She usually starts work on a new painting with sketches. "It's so important to keep the flow and spirit of the inspired sketch in the final piece." She generally uses watercolours (Winsor & Newton) and inks, combined with Staedtler watercolour pencils. She works on Peterboro Hi-Art illustration board and on an 80lb white vellum cover stock made by Finch. A painting may take anywhere from an hour to several weeks to complete, depending upon "how desperately it desires to be born". Some pieces she's happy with immediately, others she's less pleased with, "yet sometimes, six months after I create a piece I was initially unhappy with, I may come to love it."

Paulina especially enjoys designing the colours and styles of her fairies' clothes to suit their individual characters. She finds that most of

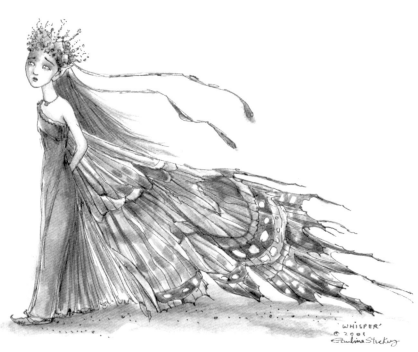

AFTERNOON TEA (*FACING PAGE*)
8½ x 11 in. Watercolour, ink and watercolour pencils. 2002.

There's nothing like sharing tea to warm the soul, and faeries love to partake in such pleasantries, too. I didn't know what was going to happen with this piece, so I simply allowed my inspirations to take me away to that fanciful world of magic.

WHISPER (*LEFT*)
5 x 7 in. Watercolour, ink and watercolour pencils. 2001.

Most of the faeries who visit me will mirror my exact mood at the moment of their conception. Whisper is the gothic, theatrical side of me.

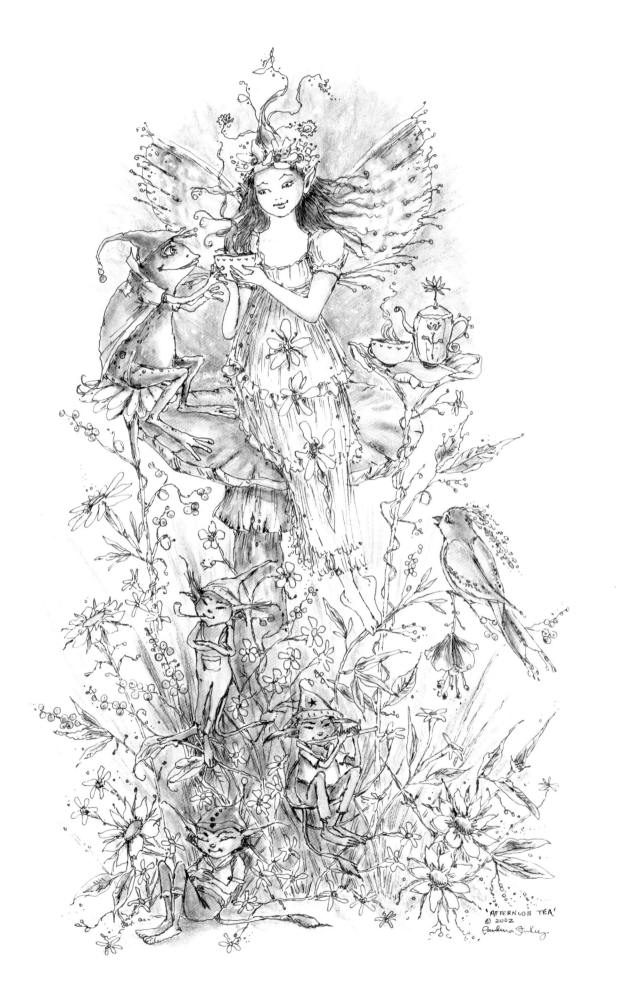

'AFTERNOON TEA'
© 2002
Paulina Stuckey

> *"My inspirations come from many sources: the moon, forests, autumn, birds, wildflowers, the sky, open fields, clouds with faces, thunderstorms, the ocean, dreams, books, twisted trees, cats; in fact, all animals, spirits, ghosts, gardens, magic and the mysterious.* "*

them appreciate being given a graceful set of antennae as well as hats or garlands of leaves, berries or flowers. Wings vary in shape and size, usually being designed to match the costume. Paulina adds wryly: "Fairies like to be acknowledged, but they can be stubborn, expecting to be pleased with my interpretation of them." Some of her wonderfully whimsical fairies are on display at www.paulinastuckey.com.

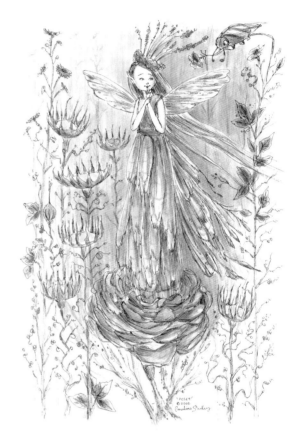

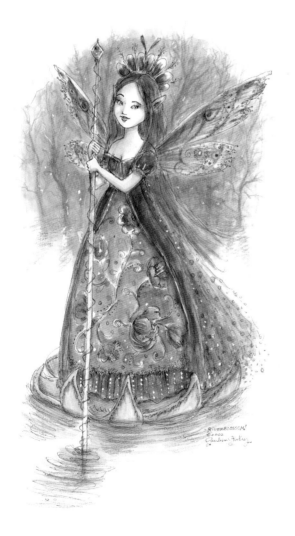

POSEY *(ABOVE)*
8 x 10 in. Watercolour, ink and watercolour pencils. 2002.

A joyous piece in celebration of spring. Posey is one of the young faeries who finds delight in the surprises this season brings forth – sunshine, colours and the sweet scent of blossoming flowers.

RIVERBLOSSOM *(LEFT)*
8½ x 11 in. Watercolour, ink and watercolour pencils. 2003.

Riverblossom is a water faerie related to the kingdom of the dragonflies. I'm pleased with the way the colours work together. There's an expression in her face that seems to say, "join me in my journey, as there are wonderful secrets to be discovered."

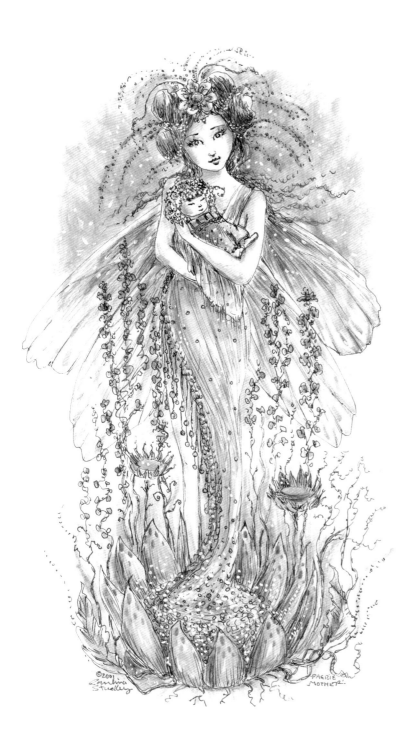

FAERIE MOTHER *(LEFT)*
8 x 10 in. Watercolour, ink and
watercolour pencils. 2001.

I wanted to portray a sense of softness
and warmth with this piece. *Faerie
Mother* represents the innocence of life,
and the power of love's protection. It has
especially proven to be a popular image
with mothers and mothers-to-be.

GREYE *(RIGHT)*
5 x 7 in. Watercolour, ink and watercolour pencils.
2001.

Greye represents that frozen time in the grey ether
when one finds oneself lost in the melancholy, with
only feeling and without thought. Though lost in such
moments as this, this faerie knows she'll find the
strength to fly again, even higher than before.

QUEEN OF THE BLUE ROSE (*ABOVE*)
8¼ x 10½ in. Pencil, Adobe Photoshop 6.0. 2002.

I was watching a TV programme about flowers, and roses in
particular. "Whilst various colours have been created by
people's hands, only blue has never been done" someone said.
Blue therefore has a special meaning for fairies, a colour
created solely by nature.

# RYU TAKEUCHI

*" Fairies are creatures of our imagination, yet are very real to me.
It's very interesting for me to draw them with their forms and poses,
and feel the palette of nature's colours. "*

Born in Tokyo in 1967, Ryu Takeuchi in childhood drew the animated characters he saw on television. It was as a teenager that he discovered the wider world of fantasy through an interest in the great illustrators, among them Amano Yoshitaka, Alphonse Mucha and the animator Nagura Yasuhiro. It was, however, the discovery of the work of Arthur Rackham that kindled in him the passion to paint fairies. For a while he worked in a pharmacy, but in his late twenties he was pulled back to his love of drawing by the new opportunities opened up by computer graphics and the internet.

He starts with sketches – "I take my sketchbook with me everywhere" – and then uses Adobe Photoshop to develop the images. His fairies have slender bodies "drawn with the consciousness that they are of human form, yet are not human". He derives their wings from the wings of insects. His colour preferences tend towards the blues: "I think blue represents clean and noble, light and innocence." His work is on show at www.bekkoame.ne.jp/ro/ziki.lai.

EMERALDA *(ABOVE)*
6 x 7¾ in. Pencil, Adobe Photoshop 6.0. 2002.

I drew this form as simply as possible with care to achieve a good balance between the foreground and background colour, which can often be quite a difficult process.

MARGARET *(LEFT)*
7¾ x 10¼ in. Pencil, Adobe Photoshop 6.0. 1999.

The sound of the name "Margaret" influenced me more than the shape of the flower. She has a quality of pure girlishness and she is taking a step to becoming an adult, which is reflected in the white colour of her dress.

# KIM TURNER

*" I try to capture the essence of the fairy as it would be if you came upon it somewhere, going about its business, and it stopped long enough for you both to look at each other's world. "*

**B**orn in 1972 in Toronto, Kim Turner moved with her family when she was five to Australia, where she now lives. She lists Brian Froud, Alan Lee, Arthur Rackham, Cicely Mary Barker and William Bouguereau among her artistic influences, but pre-eminently John William Waterhouse: "I was lucky enough to see his works in the Tate Gallery. They are so much more breathtakingly beautiful than the images you see of them as prints and calendars. The depth and detail are simply amazing."

Kim had formal art training under Barbara Cheshire. She works in watercolour pencils, her technique being essentially one of layering. After brief sketching, she does the underpainting in several layers of very weak washes until the form starts to appear, then she starts on the fine detail using the pencils. She always begins with the face. She likes the earth hues, and employs warm colours for fairies to give them a sense of energy. She uses black a lot in her illustrations as a symbol of the subconscious, the unknown, night and mystery, "to extend the imagination of the viewer to what may be lurking in those shadows".

Her website is at http://home.austarnet. com.au/moiandkim.

CHLORIS *(ABOVE RIGHT)*
11½ x 16½ in. Watercolour and gouache. 2002.

Every illustration is an opportunity to create a world, or a moment in a world. For this faerie I drew on the myth of Chloris, the goddess of spring; she is languid and dreamy, a warm, sensual earthy kind of faerie, a sort of "siren", and she symbolizes the promise of rebirth and renewal.

FINN *(RIGHT)*
11½ x 16½ in. Watercolour and gouache. 2003.

The inspiration for *Finn* came to me during a family picnic, when I saw a friend's child sleeping peacefully in a field. My passion for creating this illustration was inspired by his facial expression. Beauty, innocence and trust are what this image means to me.

CELESTE (*ABOVE*)
11½ x 16½ in. Watercolour and gouache. 2003.

For *Celeste* (meaning "heavenly"), I was eager to
create a faerie as a "spirit of the night"; an ethereal
creature of the shadows. I wanted to render the
essence of a faerie only ever seen flitting across dark
moors beneath the light of a blue moon.

# MARIA J. WILLIAM

Born in 1974 in Eastern Europe and raised there, Maria J. William moved to the USA in 1994 and now considers herself a New Yorker at heart. Like so many other artists represented in this book, she started drawing and painting so early she now cannot recall a time when she did not. Her parents tried to expose her to art, but under Soviet rule, which prescribed "good" and "bad" art, this was not easy; the bureaucrats disapproved of fantasy and spirituality, so little fantasy art and spiritual art was available to the public. She was thus in her teens before she properly encountered fantasy.

Among her early creative inspirations she lists Jules Verne, Shakespeare, Harper Lee (author of *To Kill a Mockingbird*, 1960), The Beatles, J.R.R. Tolkien and Boris Vallejo; more recent are writers Dan Simmons, Octavia Butler, J.K. Rowling and China Miéville. Artists who have influenced her include William Bouguereau, Alphonse Mucha, Tim White, Brian Froud, Brom, Michael Parkes, Olivia, Vargas, Gil Bruvel, John Pitre and the Pre-Raphaelites. She trained in music and ballet as a child, "Music is one of the greatest influences on my art."

Maria has no formal art training, but since meeting Boris Vallejo and Julie Bell in 1994 she has received a "tremendous amount" of practical advice from them. She has also recently attended the Art Students' League of New York. She has worked for writers, private clients and role-playing-games companies.

She uses mostly traditional media: graphite, coloured pencils, watercolours, gouache and oils; occasionally she tweaks her final images on the computer. She used to work mainly in oils on illustration board, but at the moment favours coloured pencils: she uses them for 90 per cent

> " *Is it imagination that makes me want to paint?*
> *It's not as simple as that. Imagination is the vehicle*
> *by which the ideas are shaped and transferred;*
> *what creates them lives deep within and*
> *cannot really be named.* "

AFTER THE RAIN *(RIGHT)*
11 x 14 in. Coloured pencil and sepia ink. 2002.

This simple image started as a flower study, but later grew into something more. As with many other artists who draw fairies, I owe a great deal of inspiration to Cicely Mary Barker's fairies, and this drawing reflects that. The fairies may have become more contemporary, but the innocence and the sweet simplicity remain.

A NEW DRESS *(FACING PAGE)*
11 x 14 in. Coloured pencil and Micron pens. 2002.

My love for a lot of art styles is reflected here, in particular Neo-classicism and Art Nouveau.

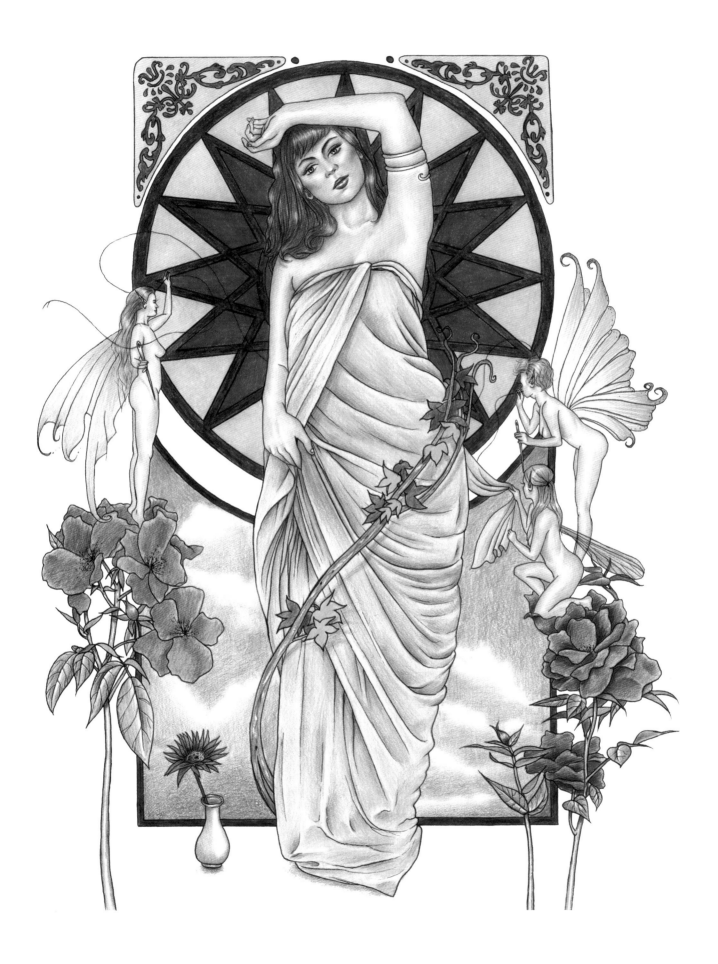

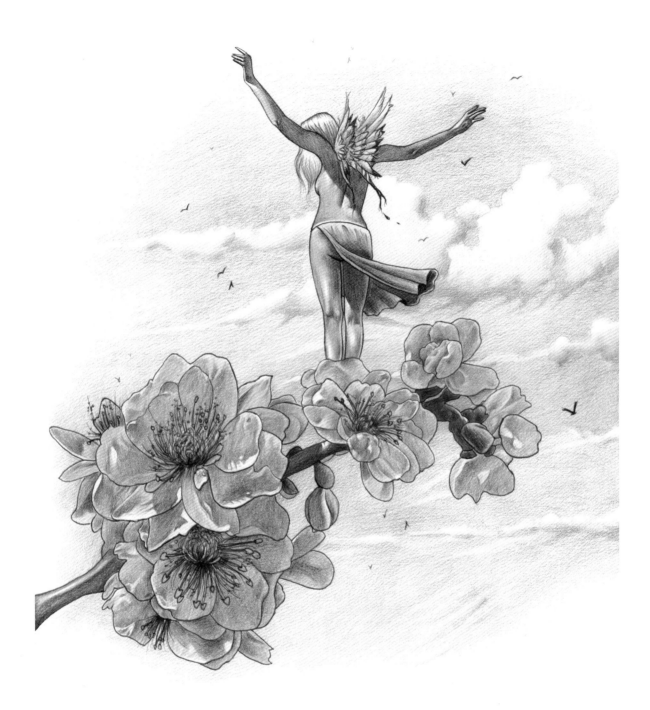

of the drawing, then finishes with light outlines in sepia ink, and sometimes a light wash of watercolour. For black-and-white drawings she uses a combination of mechanical and regular pencil.

Aside from fairies, she also paints angels, mythological and fantasy subjects, children (her young son James is her favourite model), apocalyptic subjects and pin-ups. Her website, www.mariawilliam.net, features her work in all these styles.

DREAMING OF FLIGHT *(ABOVE)*
11 x 14 in. Coloured pencil and sepia ink. 2002.

This drawing was inspired by one of my favourite fantasy writers, China Miéville, and in particular one of his characters – a birdman who has lost his wings and would give anything to fly again.

DAWN *(FACING PAGE)*
11 x 14 in. Coloured pencil and sepia ink. 2002.

Fairies are often portrayed wearing clothing, which has always made me wonder as to where they got it. Is there some sort of a fairy tailor? Why don't fairies simply wear flowers?

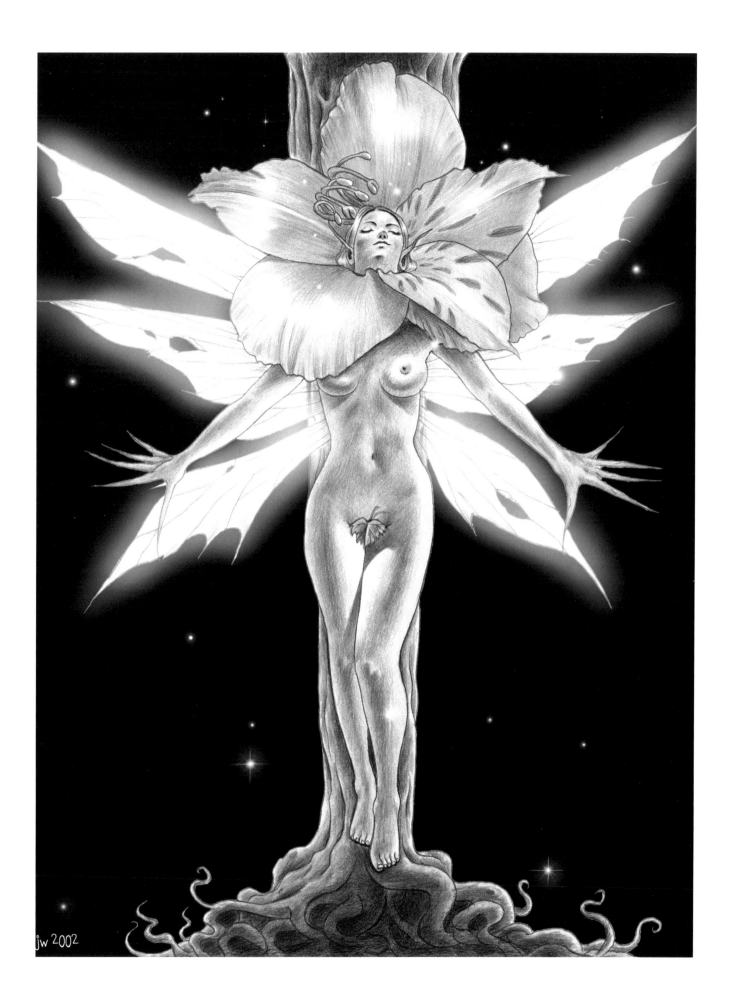

jw 2002

# ARTIST WEBSITES

For more information on the artists featured in *The Art of Faery* see the list of artist websites and related sites below. These sites contain galleries, biographies, links and information on purchasing and commissioning work. Contact email addresses have also been supplied where possible.

**JOHN ARTHUR**
Website:
www.johnarthur.com
Email:
johnart5@juno.com

**HAZEL BROWN**
Website:
www.faery-art.com

**JULIE BAROH**
Website:
www.juliebaroh.com
Email:
jbaroh@juliebaroh.com

**JAMES BROWNE**
Website:
www.jamesbrowne.net
Other sites:
www.elves-pixies.com
Email: james@jamesbrowne.net

**JASMINE BECKET-GRIFFITH**
Website:
www.strangeling.com
Email:
jasmineToad@aol.com

**JACQUELINE COLLEN-TARROLLY**
Website:
www.toadstoolfarmart.com
Email:
jacqueline@toadstoolfarmart.com

**LINDA BIGGS**
Website:
www.fairieforest.com
Email:
info@fairieforest.com

**DAVID DELAMARE**
Website:
www.daviddelamare.com
Email:
delamare@teleport.com
Tel: (Toll-free)
1-888-666-5399

**AMY BROWN**
Website:
www.amybrownart.com
Other sites:
www.fairyfantasia.com

**MAXINE GADD**
Website: www.fataraworld.com

**JESSICA GALBRETH**
Website:
www.enchanted-art.com
Other sites:
www.fairyvisions.com
www.fairynight.com
Email:
Jessica@enchanted-art.com

**ANN MARI SJÖGREN**
Website:
www.fairypaintings.com

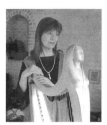

**MARJA LEE KRUŸT**
Website:
www.visionary-artist.co.uk
Other sites:
www.endicott-studio.com/biokruyt.html

**PAULINA STUCKEY**
Website:
www.paulinastuckey.com
Email:
paulina@paulinastuckey.com

**MYREA PETTIT**
Website:
www.fairiesworld.com
Other sites:
www.fantasy-artworld.com
Email: myrea.pettit@fairiesworld.com

**RYU TAKEUCHI**
Website:
www.bekkoame.ne.jp/ro/ziki.lai
Email:
ziki.lai@ro.bekkoame.ne.jp

**NATALIA PIERANDREI**
Website:
www.nati-art.com
Other sites:
www.flowerfaeries.com

**KIM TURNER**
Website:
http://home.austarnet.com.au/moiandkim
Email:
faeriegirl@austarnet.com.au

**STEPHANIE PUI-MUN LAW**
Website:
www.shadowscapes.com
Email: stephlaw@shadowscapes.com

**MARIA J WILLIAM**
Website:
www.mariawilliam.net
Email:
maria@mariawilliam.net

**LINDA RAVENSCROFT**
Website:
http://mysite.freeserve.com/ravenart
Other sites: www.duirwaighgallery.com
Email: Linda@ravenart.fsnet.co.uk

**BRIAN FROUD**
Website:
www.worldoffroud.com
Other sites:
www.fantasy-artworld.com

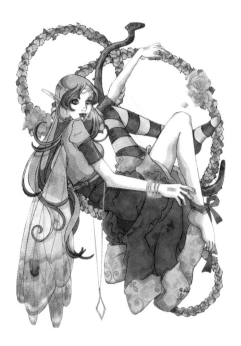

# ACKNOWLEDGEMENTS

David Riché would like to thank the following people who helped with this volume:

This book would not have been possible but for the great help of all the contributing artists whose work I have long admired and their enthusiasm to support me in this project. My thanks go to all of you, and to my fairy daughters and friends for their encouragement.

I am indebted to the faery genius of Brian Froud; for his wisdom and understanding, his contribution to, and recognition of, the artists for whom he has had great influence. His years of vision have given so much understanding and pleasure to generations worldwide with his authoritative understanding of the World of Faery.

I would like to thank Robert Gould, Alan Lee, Wendy Froud and Terri Windling for their knowledge in matters Faery and their encouragement, Per Arne Skansen for his research in Sweden and subsequent discovery of Ann Mari Sjögren and Lena Lindh, Izumi for her Japanese/English translation and communication with Ryu Takeuchi, Christopher and Sharon Spriggs of *www.fairyletter.com* for the use of their commission *Aurelia* by Myrea Pettit, the staff at Collins & Brown: Colin Ziegler, Kate Kirby, Emma Baxter, Miranda Sessions and Serena Webb, for their support and enthusiasm, Kaye for passing on messages, designer Malcolm Couch, Ray Danks for his web design of www.fairyartists.com and my author friend Vicente in Medellin, Colombia, for his words of faery wisdom which helped me to believe, and for the use of his *Oldest Librarian* (see page 72). *www.fairygirls.com*.

*"Most people haven't seen the fairies. And how are they going to see the fairies if they don't believe in them? The fairies aren't fools, they are not going to show up, except to people that love and esteem them."* © Vicente Duque